GREATEST
WESTERNS

IN ASSOCIATION WITH
TIMPSON

GREATEST
WESTERNS

BARRY STONE

Published in the UK in 2016 by
Icon Books Ltd, Omnibus Business Centre,
39–41 North Road, London N7 9DP
email: info@iconbooks.com
www.iconbooks.com

Sold in the UK, Europe and Asia
by Faber & Faber Ltd, Bloomsbury House,
74–77 Great Russell Street,
London WC1B 3DA or their agents

Distributed in the UK, Europe and Asia
by Grantham Book Services, Trent Road,
Grantham NG31 7XQ

Distributed in Australia and New Zealand
by Allen & Unwin Pty Ltd,
PO Box 8500, 83 Alexander Street,
Crows Nest, NSW 2065

Distributed in South Africa by
Jonathan Ball, Office B4, The District,
41 Sir Lowry Road, Woodstock 7925

Distributed in India by Penguin Books India,
7th Floor, Infinity Tower – C, DLF Cyber City,
Gurgaon 122002, Haryana

Distributed in Canada by Publishers Group Canada,
76 Stafford Street, Unit 300, Toronto, Ontario M6J 2S1

Distributed in the USA by Publishers Group West,
1700 Fourth Street, Berkeley, CA 94710

ISBN: 978-178578-098-1

Images – see individual pictures

Typeset and designed by Simmons Pugh

Printed and bound in the UK by Clays Ltd, St Ives plc

ABOUT THE AUTHOR

Barry Stone is a travel writer and author of eleven non-fiction books covering subjects as diverse as mutinies in the Age of Sail, historic Australian hotels and sporting scandals. His first book, *I Want to Be Alone*, a historical study of hermits and recluses, has been translated into Standard Chinese.

His affection for western movies, however, long pre-dates all of that. *The 50 Greatest Westerns* has been a long time coming. A frequent attendee of local and international film festivals and western retrospectives, he now offers up a very personal 'Best 50 List'. He lives in Sydney, Australia.

CONTENTS

INTRODUCTION

For my father,
who loved watching westerns with me
and for my friend Dave Card,
who always made me laugh

The western movie is America's genre, in the same way that jazz is its music and baseball its sport. More than any other film type, it embodies traits that Americans have always laid claim to, with its central theme of 'civilisation versus wilderness' providing the spark for a young nation's energy, inventiveness, persistence and individualism. Audiences everywhere, regardless of whether they lived on the plains or in teeming cities, connected with its themes because the further you wind back the clock of white settlement in the New World, the more you're reminded the *entire nation* was once one vast, unexplored frontier. In the early 1500s, and for the next two centuries, wilderness was everywhere.

America's 'wild west', when it finally did come in the wake of the Civil War, came and went with a rush in just a few decades, a remarkable achievement when you consider it took three hundred years for its fledgling communities along its Atlantic coast just to expand to the eastern banks of the Mississippi River! Little time was lost, too, in mythologising it. Artists like Thomas Cole (*Daniel Boone Sitting at the Door of His Cabin on the Great Osage Lake*, c.1826), Emanuel Leutze

(*Westward the Course of Empire Takes Its Way*, 1861) and Albert Bierstadt (*Emigrants Crossing the Plains*, 1867) painted stylised representations of Eden-like landscapes that, intentionally or not, promoted the idea of 'Manifest Destiny', the belief that westward expansion at any cost was both inevitable and wholly justified.

In literature the mythology of the west that would one day be taken to undreamt-of levels by Hollywood had its origins in the series of books called the *Leatherstocking Tales* by James Fenimore Cooper. Written from 1823 to 1841, Cooper popularised the adventures of Natty Bumppo, a young man who spent his youth hunting with the Delaware Indians before living for a time in upstate New York where he watched with dismay its transformation from wilderness to farmland, eventually ending his days an old man on the Great Plains. Now considered American literary classics, Cooper's work on the virtues of wilderness and personal freedom saw him contribute more than almost any other single 19th-century American to the creation of an idealised frontier. Long before movie cameras ever began to roll, the west had been mythologised in art and literature, with the nation's most iconic landscapes – the Rocky Mountains, the Grand Canyon, the prairies – already on a descent into the mire of nostalgia. In 1893, three years after the Massacre at Wounded Knee and the end of Native American resistance, the frontier was pronounced officially closed. The 'wild' west was suddenly the stuff of legend. Then, just ten years later, before the dust on it had barely settled, along came Hollywood ...

The historical west never remained static for long, its growing pains open wounds for all to see: the murder and displacement of its Native Americans, the slaughter to near-extinction of the buffalo, the carving up of the prairies in

the wake of the Homestead Act, the greed that came with the Trans-continental Railroad, the lawlessness, the rush for gold and silver. And for this reason we see, too, the evolving nature of the film genre. From *The Great Train Robbery* of 1903 – twelve minutes of oh-so-precious images that contain in its innocence all of the plot lines of the coming 50 years – to the arrival of the silent epics *The Covered Wagon* (1923) and *The Iron Horse* (1924).

The genre's first Mega-star, Tom Mix, appeared in hundreds of feature films from 1909 to 1935 and defined the cowboy persona for a generation. The era of the 'singing cowboy' reached its peak in the late 1930s with actors like Gene Autry and Roy Rogers expressing their emotions through song. In 1939 we saw the fresh-faced Ringo Kid of *Stagecoach*, a masterpiece that lifted the western into unchartered cinematic territory. After the carnage of the Second World War came the psychological, brooding anti-westerns and impassive heroes of directors Anthony Mann and Budd Boetticher, though by the end of the 1950s and early 1960s, despite – or perhaps because of? – the popularity of television shows like *Gunsmoke* and *Wagon Train*, western cinema audiences were dwindling. Yet they refused to lie down. Whenever a eulogy over the demise of the western was trotted out by film critics who should have known better, the western would reinvent itself and charge back like the proverbial cavalry: *The Wild Bunch*; *Unforgiven*; *Django Unchained* ...

Sub-genres came along too, to remind us that the western could be far more than we ever imagined it could be. The spaghetti westerns of the 1960s began with a series of overlooked Italian/Spanish co-productions until Sergio Leone's *A Fistful of Dollars* and Sergio Corbucci's *The Great Silence* forever changed the genre with their emphasis on

bleak landscapes, moral ambiguities, raw violence and anonymous anti-heroes with mean-looking handguns that at last looked capable of really making a mess of someone. The late 1960s and early 1970s saw the emergence of the counter-culture 'acid' westerns, with their emphasis on death and decay. Science fiction westerns such as *Outland* skilfully transplanted familiar themes – in this case the loneliness and abandonment felt by Gary Cooper's Will Kane in *High Noon* – into the curiously western-like frontiers of space. Those who might criticise *Outland* for drifting too far from long-established themes fail to comprehend the genre's potential.

The western, it turned out, was never going to be kept to silly notions of time or place. Mann and Boetticher knew this only too well, and must have chuckled to themselves as they hoodwinked studio producers who gave them money for what they thought were westerns, thus enabling these two visionaries to continue to dabble in their pursuit of the noir and the psychological. And then there is the rise of the neo-western, the traditional western retold in a contemporary, even urban, setting. Increasingly, too, myths were laid to rest with films such as *The Assassination of Jesse James by the Coward Robert Ford*, a contemplative work that showed the outlaw to be deeply flawed and laid waste to America's obsessive idolisation of common gangsters. Jesse James, like Butch Cassidy, the Sundance Kid and Pike Bishop's Wild Bunch, lived long enough to become irrelevant, suffocated and marginalised by a shrinking frontier no longer recognisable because it was no longer wild.

In the early 1800s, American legislators in their ignorance saw everything that lay beyond America's 98th meridian, that north–south line that to this day still separates the forested, well-watered east from the open plains of the west, as being

unfit for cultivation. It was a vast unknown called simply the Great American Desert, a term attributed to the early 19th-century botanist and explorer Edwin James. But every country has its wilderness, its untamed places and people everywhere know too well their own inner demons. We are all flawed, imperfect creatures, yet because the western movie remains cinema's most primeval genre it is the genre that best speaks as to what ails us. Its themes are universal, and will continue to find resonance with new generations of filmgoers, who will always prefer a wilderness of possibilities, with all its potential and pitfalls, to the shackles and deadening melancholy of civilisation.

And, Mr Quentin Tarantino, a big thank you. Let's have lunch. I have an idea for a screenplay ...

THE 50 GREATEST
WESTERNS

50. *OUTLAND* (1981)

What makes a western, a western? Is it just a collection of the right sort of landscapes, of flat-topped mesas, the Great Plains or the Black Hills of South Dakota, the backdrops one expects to see? Just stick a few buffalo in front of the lens, or the dusty streets of a frontier town, or a wagon train or a shootout, set it somewhere west of the Mississippi anytime between 1780 and 1900 before the arrival of electricity and motor cars, and there you have it? Or are westerns harder to pin down? Perhaps there's more to the genre than what critics have always said are its Achilles heels: too one-dimensional, too predictable, too few locations, not enough variety. What if whether a movie is a western or not depended on more intangible things, like how it feels to be alone and outnumbered, what it's like to be a long way from home in an alien land, or having to wear a gun everywhere you go and living by your wits in an environment that can kill you, but which isn't nearly as dangerous as your ultimate enemy: man? Even in the wild west, man was still the ultimate predator. Maybe what is true on the Great Plains can be just as true on the moons of Jupiter.

I recently watched *Outland* again after not seeing it for maybe twenty years, and it looked every bit as gritty and taut, tense and plausible as it did before. Sean Connery is Marshal William O'Niel, a Federal District Marshal who has been sent to investigate a titanium mining colony on the Jovian moon of Io, where the miners have been dying in a rather gruesome series of apparent acts of suicide by exposing

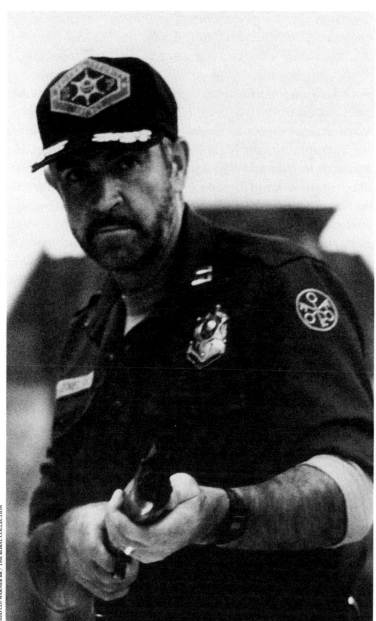

themselves to the moon's zero atmosphere, resulting in the explosive decompression of their bodies. O'Niel discovers that the colony's high rate of productivity is the result of an illegal supply of deadly narcotics that allow the miners to work for days at a time until they eventually burn themselves out and become psychotic. The colony's administrator, Mark Sheppard (Peter Boyle), is determined to maintain the corrupt and highly profitable status quo and hires two assassins to come on the next supply shuttle to kill O'Niel, who becomes aware of what is coming and prepares himself for the confrontation. Digital clocks throughout the colony continually count down to the arrival of the shuttle. O'Niel is ostracised and very much on his own, always having to watch his back. The tension builds relentlessly, helped along by the ominous, almost hypnotic counting down of those digital clocks, until the shuttle's arrival heralds the final showdown.

Peter Hyams, the American director, cinematographer and screenwriter, was interested in making a western movie set in a science fiction context, and refused to believe the early 1980s misplaced conception that the western was dead. He triumphantly transfers the motifs and characters of countless 19th-century frontier towns to Io, and not only that but took the opportunity to add a nice corollary on corporate greed as well. The result? *Outland* becomes a thoughtful futuristic homage to – and adaptation of – the great 1952 classic *High Noon*, in which Gary Cooper plays a marshal abandoned by the very people he has sworn to defend, waiting for the arrival of a train carrying his own would-be assassins.

O'Niel's only ally is the company doctor, Dr Lazarus (Frances Sternhagen), who somehow remains sufficiently detached from the corruption swirling about her and assists O'Niel in unravelling the complicity of the mining company

– Conglomerates Amalgamated – and then going further, helping O'Niel to dispatch the first of the hired assassins. The second is also killed, as is the corrupt Sgt. Ballard (Clarke Peters), O'Niel's own deputy, before a final confrontation with Sheppard whom O'Niel knocks out and whose ultimate fate – either killed at the hands of his own accomplices or brought to trial – can be left to the discretion of the viewer. O'Niel then boards the next shuttle back home to his family, and a very frontier-like brand of justice again wins the day.

Outland was the first film to use Introvision, a twist on traditional front projection techniques that allowed actors to be placed between plate images, to in effect walk *inside* a two-dimensional background image. Introvision remained popular until the era of digital compositing in the mid-1990s. The enduring images of this timeless film for me, however, remain the shotgun O'Niel chose to use in his defence – a very deliberate 'relic' and a nod to the Remingtons and Winchesters that helped subjugate the old west. And of course there was the wonderful sound of that digital clock, relentlessly ticking, ticking, ticking, counting down the seconds in a claustrophobic-looking future full of shadows and steam and steel grates reminiscent of Ridley Scott's masterpiece *Alien*, which had been released two years earlier.

Unlike *Alien*, though, which frightened us out of our seats with acid-filled monsters, *Outland*'s message is far more chilling. It reminds us that technology, the future and the colonising of space will not by default mean that we will be triumphing over our inner demons. It reminds us that though Io may be far removed from the Great Plains and the Black Hills and the Colorado Plateau, from Tombstone and Dodge City and *High Noon*'s Hadleyville, the western is not about a certain time, a particular place or a costumed look. It is far more sinister than that. The west is everywhere that

mankind goes to that is new and untamed, every place where the law is absent and greed simmers. It reminds us that even in the dark, cold reaches of outer space, the ultimate enemy will still be man.

49. *WESTWORLD* (1973)

Yul Brynner echoes his 'Man in Black' character of Chris from *The Magnificent Seven* as an android known only as 'The Gunslinger' in this endearing sci-fi/western thriller, written and directed by Michael Crichton and based on his own best-selling book. The plot centres on a futuristic resort for adults called Delos, which consists of three themed worlds: the debauchery of Roman World, the fantasy of Medieval World and the lawlessness of West World. Drawing his inspiration from Disneyland, Crichton's high-tech park is populated by purpose-built androids all controlled and maintained by a hidden throng of technicians, androids that exist purely for the pleasure and amusement of the park's guests. Naturally, not long after the arrival of the film's two central characters, played by Richard Benjamin and James Brolin, who are happy to pay the resort fee of $1,000 a day to have the adventure of a lifetime, things begin to go horribly wrong as androids begin turning on guests, hunting them down and killing them in a frenzy of wanton violence.

Westworld is unashamedly cliché-ridden, with almost every scene done a thousand times before in the genre. But that mattered little to this impressionable teenager and movie-goers everywhere who, for the very first time in motion

pictures, became privy to an electronic, pixelated view of the world as seen through the eyes of The Gunslinger – the sort of voyeuristic glimpses audiences have since become so accustomed to seeing through the eyes of Schwarzenegger's Terminator. Crichton wanted to go a step beyond the wide-angled lens approach used to such good effect in *2001: A Space Odyssey* when Stanley Kubrick showed audiences the elongated world as the computer HAL saw it. In *Westworld*, using digital image processing, Crichton crafted a visual masterstroke that seared those pixelated images deep into the audience's psyche.

And it almost didn't happen. Crichton badly wanted this never-before-seen effect, but because of the studio's miniscule budget ($1.25 million) he couldn't afford the $200,000 that NASA's Jet Propulsion Laboratory wanted for doing it (nor could he wait out their projected timeframe of six months). So he turned instead to a budding computer graphics artist, John Whitney Jr, the son of John Whitney Snr the great animator and analogue guru, who gave him the look he wanted for a tenth of the cost. *Westworld* went on to win a number of prestigious science fiction and fantasy awards for its special effects.

Almost all its scenes were shot using standard lenses, though its budget was stretched to breaking point by Crichton's insistence on using rear and front projection, as well as blue screen – special-effects techniques usually reserved for directors with more generous allowances. The budget was so small in fact that the art director, Herman Blumenthal, had a paltry $70,000 for set construction, forcing him to re-use sets on different locations and hoping no one would notice. Even Yul Brynner, who was experiencing lean times himself, agreed to do the film for a modest $75,000. And there were the usual on-set mishaps. Brynner was hit in the eye

from the wadding off a blank cartridge and had his cornea scratched. Brolin was bitten by a rattlesnake while preparing for a scene when the fangs from its lower jaw penetrated the arm protector he was wearing under his shirt sleeve.

Crichton would revisit his idea of an amusement park running amok years later in *Jurassic Park*. But it wasn't the robotics that thrilled me as much as seeing Brynner parody his character from *The Magnificent Seven*, my favourite film of my childhood. One day on the set Brynner, who was teaching Richard Benjamin how to shoot a gun, gave up one of the secrets as to what makes a believable gunman when he said: 'You look at the biggest western stars, and I'll show you that they blink when the gun goes off'.

When the finished film was shown to studio executives nobody liked it, but the preview audiences came back with an astonishing 95 per cent approval, one of the highest in the studio's history. It is not without its flaws, but *Westworld* is an example of how a fresh idea, worked on by a cast and crew who cared about what they were doing, could deliver a film that is neither profound nor silly. And it proves that the clever use of technology combined with a seemingly unstoppable bad guy can produce a film that is immune to becoming dated when set in that most mythic era of time and space, the American west.

48. *THE IRON HORSE* (1924)

No single event did more to tame the wild west than the completion of the First Transcontinental Railroad in 1869, a 3,069 km/1,907 mile railway line that took the

existing eastern rail network westward from Council Bluffs in Iowa to San Francisco Bay on the Pacific coast. Three independent railroad companies combined to complete it, and the famous 'Last Spike' was driven in on Promontory Summit, Utah, on 10 May 1869. At long last the vision of Dr Hartwell Carver, the 'father of the Pacific Railroad', whose 1832 article in the *New York Courier and Enquirer* would be the first of his many petitions to Congress to find the funds to build it, had been realised.

Forty-five years after the hammering in of that final spike, a young John Ford came to Hollywood and found work as a stunt double before being given his first directorial debut in 1917 with *The Trail of Hate*, the first of many two-reelers. The idea of the 'epic' western had arrived in 1923 with Paramount's *The Covered Wagon*, which single-handedly revived the public's waning interest in the genre and proved so popular with audiences that Ford, by now working for the Fox Film Corporation (later 20th Century Fox) and a veteran director of more than 50 films, was given what became the most significant western of his silent period – the story of the building of the First Transcontinental Railroad, *The Iron Horse*. The man who, more than any other director in Hollywood, would laud and glorify the freedom and expansiveness of the frontier, was recreating the one event that did more than any other to bring it to a close.

The film's 300-plus cast and crew were housed in twenty rented Pullman railroad sleeper cars or slept in the clapboard interiors of the town sets they'd built, and filming took place on the barren desert flats around the town of Wadsworth, Nevada, in the bitter winter of 1924 when snowfalls would routinely cover the sets. The film, which began without a script and with little more than a synopsis, sets its story against the relentlessly encroaching

Central Pacific Railroad and Union Pacific Railroad companies as they close in on Promontory Summit. It recounts the life of Davy Brandon (played as an adult by George O'Brien, a former stuntman and camera assistant), who as a child witnesses the death of his father, a surveyor who dreamt of building a railway to the west, at the hands of a half-breed Cheyenne (Davy's back-lit frame as he stands over his father's dead body also gives the film its only real expressionistic, noir moment). Fast forward to 1862 and Davy, now a strapping scout and frontiersman, has his own dream – to see the completion of his father's ambition after the bill authorising its construction is finally signed into law by President Abraham Lincoln.

Many later 'Fordian' trademarks are already evident, including the pastoral nature of the landscape, the sense of 'Manifest Destiny' that drove pioneers ever-westward, the presence of the labourer and the immigrant on whose backs the west was built, and the innocence of the land when seen through the eyes of children. Ford also wanted the film to look as historically accurate as possible, managing to gather together 10,000 head of cattle and over 1,300 buffalo, as well as studying photographs of the actual 'Last Spike' ceremony in order to recreate it on film. The movie also had at its disposal two very impressive 'Iron Horses' of its own – two steam locomotives that some said were the very same that met nose to nose at Promontory Summit on that historic day. As nice a touch as that would have been, unfortunately they were not. The two engines, the 'Jupiter' and the 'UP 116', had long since been scrapped.

Ford had a personal connection with the railway. A family relative, Michael Connolly, sponsored his own father's migration from Ireland and was a construction worker on the Union Pacific line, a fact that may have contributed to Ford's

tendency in the film to side with the workers in their struggle with the unfettered capitalism of the railroad companies and his sympathetic depiction of the various immigrant groups (Irish, Chinese, Italian and African-Americans) who together forged some unlikely communities.

The fact the film had a fairly typical B-movie storyline was forgotten in the wake of its scale and staggering success. *The Iron Horse* made more than $2 million in America and became the year's top-grossing movie. The film's sweeping cinematography, particularly in its images of Indians racing across the landscape on horseback, combined with great stunt work, richly orchestrated crowd scenes and a realism born of its epic scale, showed here was a director who was clearly in a period of personal transition, from a mere deliverer of two-reeled 'pulp' to a man becoming adept at communicating his own vision of the west – a vision that would determine how the frontier would be imagined by movie-goers for generations to come.

47. *TRUE GRIT* (1969)

Both film versions of Charles Portis' novel of how a fourteen-year-old girl from Arkansas, Mattie Ross, hired tough US Marshal Rooster J. Cogburn to help her hunt down and bring to justice her father's killer, Tom Chaney, have found their way into my list; the 2010 adaptation by the writer/director team of Joel and Ethan Coen, and the original 1969 version with Kim Darby as Mattie, John Wayne as Rooster, and singer Glen Campbell as the

Texas Ranger La Boeuf. Never claiming to be an accurate rendering of Portis' classic tale, considered by many to be one of the finest American novels ever written, John Wayne nevertheless considered the screenplay by Marguerite Roberts the best he'd ever read.

One of the doyennes of screenwriting in the 1930s, Roberts – blacklisted by the House Un-American Activities Committee in 1951 and unable to work in Hollywood for nine years – found favour once again with the big studios in the 1960s. Writing the screenplay, however, Roberts felt that the ending, in which Mattie loses her arm after a snake bite and then 25 years later visits Cogburn's grave, just too depressing. So she had Mattie and Cogburn instead visit her family plot, with Mattie offering a spot to Cogburn, and he agreeing – as long as it wasn't to be used too soon! In Roberts' version, Mattie, who was the central character in the book, almost takes a back seat to Wayne's overwhelming presence. Some might well say that the film appears a little 'flat' and in need of rescuing until John Wayne makes his appearance, and the film does lack many of the humorous asides the Coen brothers did so well, particularly in relation to La Boeuf's pride in being a Texas Ranger.

There are some notable discrepancies, too, between the novel and the 1969 film. Unlike the book (and the Coen brothers' version), the film played down the many biblical references and overtones, which were not only a nice touch but gave Mattie's quest its pervasive self-righteous aspects. La Boeuf survives in the book and the 2010 film version, but dies here. Director Henry Hathaway and screenwriter Roberts also chose not to have Mattie's arm amputated after she is bitten by a snake. The season in the 1969 version is clearly autumn, while in the book and the 2010 version it is winter. The 1969 film begins and ends with

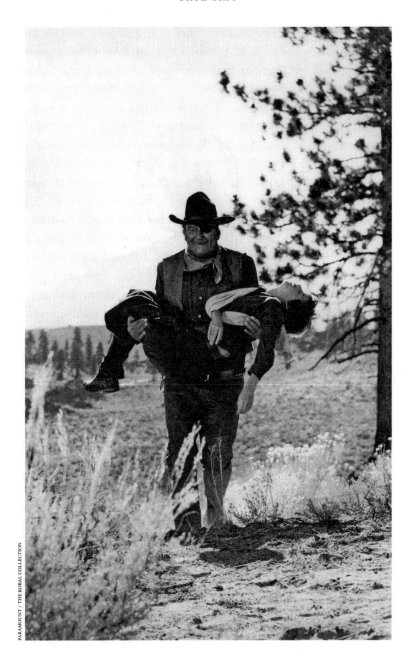

Mattie as a fourteen-year-old girl and chooses to ignore the fact that the book (and the 2010 version) begins with the aged Mattie introducing the story, and ends 25 years later with her visiting Cogburn's grave, having travelled east in the hope of seeing him perform at a wild west show in Tennessee. The fact the Coens have now produced their own interpretation of Portis' story inevitably invites comparisons, most of which simply don't go the way of the original. In every respect, the original is inferior to the 2010 remake.

Yet even considering the watered-down approach to many of Portis' themes here, particularly the shift in emphasis away from Mattie to Cogburn, the author's determined and independent Mattie Ross still shines through, and still manages to represent a pivotal point in the evolution of, and perception given to, women in the western genre. There is more than just naïve self-confidence in the character of Mattie. She is resolute, resourceful and determined to kill Chaney herself with her father's Colt Dragoon if she has to, a female having an adventure all her own instead of being the traditional representative of civility and order, always in the background in a world where men are hell-bent on acting on every destructive impulse they get. Mattie Ross determines the course, sets the pace and as an aside puts to bed the persistent and horrible notion of the 'Arkansas hillbilly'. She is articulate, confident, literate. Even here, working with a script that gives the one-eyed marshal equal screen time, and eventually a Best Actor Oscar, it remains Mattie Ross's film – and a great one, too.

46. *MY DARLING CLEMENTINE* (1946)

Universally regarded as one of director John Ford's finest westerns, *My Darling Clementine* was based on author Stuart Lake's fictionalised biography *Wyatt Earp: Frontier Marshal* (1931). Earp, who died in 1929, provided Lake with his own written accounts – some of which could be termed 'dubious' – of his adventures, and tried to control aspects of the book, which firmly embedded the Gunfight at the O.K. Corral in the American psyche, and establishing the 'mythologised' Earp as the old west's archetypal, incorruptible lawman who brings justice in his wake.

Shot over 45 days in northern Arizona's Monument Valley, Ford's favourite locale, the film opens with the Earp brothers driving a cattle train east to Kansas. They leave their brother James to ride into Tombstone and when they return James is dead and the cattle gone. Wyatt Earp (Henry Fonda) suspects Old Man Clanton (Walter Brennan) and his sons of being responsible for the murder of his brother, but instead of becoming a vigilante he goes and becomes the town's new marshal. Yes, he wants revenge, but it isn't frontier justice he's after. He wants it done legally, and he wants to be the one to do it.

What I like about this film is that the gunfight that we all know is coming, while it is hardly what one would call a footnote, is nonetheless a scene that certainly has been given its 'place'. There are more stories to tell here than the struggle between the Earps and the Clantons. There is the scene where the actor Granville Thorndyke (Alan Mowbray) comes into town to perform Shakespeare only to be tormented by the Clantons in the saloon until Wyatt

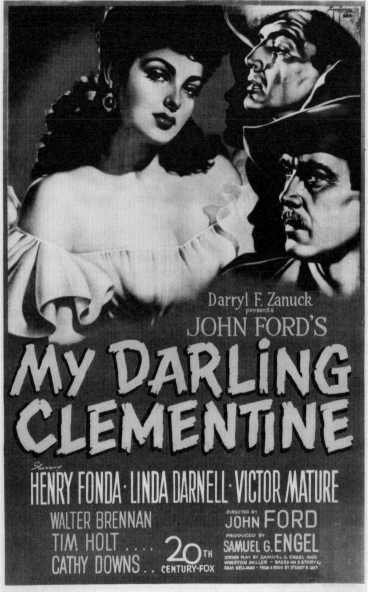

intervenes and escorts him away. And of course there is the relationship between Wyatt and Clementine (Cathy Downs), the love interest of Doc Holliday (Victor Mature) from back east who arrives in Tombstone looking for him. When Holliday tells her to leave, she meets Wyatt, and together they walk to the dedication ceremony of the town's first church. When Wyatt takes her hand and they begin to dance, it is a symbolic moment, a turning point in the history of westward expansion, no less. A lawman ... dancing? A lawman who even *knows* how to dance? The scene foreshadows what is soon to come. Civilisation, after decades of fear and lawlessness never being more than the thinnest of veneers, is about to gain the upper hand.

A number of liberties were taken in the portrayal of the film's historical characters. The Earps were never cowboys, nor did they ever herd cattle. Newman Haynes 'Old Man' Clanton died before the Gunfight at the O.K. Corral ever took place. John Henry 'Doc' Holliday survived the shootout only to later die in a clinic of tuberculosis. Clementine Carter was an entirely fictional character and, perhaps most surprisingly of all, the year in which all this happened was given in the film as 1882, when in fact it was 1881. A number of plot devices were also 'adapted' for dramatic effect, one of the more notable was the placing of Tombstone within sight of Monument Valley so Ford could have all of its evocative mesas, buttes and pinnacles as a backdrop, when in fact Tombstone lies in the deep southeast corner of the state about as far from the valley as you can get without crossing a border. Fiddling with history is not an uncommon pursuit in film making in any era, but on *My Darling Clementine* the tampering is on a truly monumental scale. It is clear that historical accuracy was not one of the film maker's primary concerns. So, what were they?

Only the second 'sound' film of John Ford's career, *My Darling Clementine* was made as the USA was emerging from the ravages of the Second World War. And there seems to be a message here from the cast and crew, many of whom served in that conflict, when one looks at the tiny one-street town of Tombstone and the arid desert that surrounds it. The idea that it's possible to build something from nothing, to create new communities, to give new hope and to press on to forge a future no matter how bleak life might appear to be.

45. *THE GREAT TRAIN ROBBERY* (1903)

We are fortunate to still have in our possession the twelve precious minutes of the one-reel film *The Great Train Robbery*. Film historians estimate eight out of ten of all motion pictures made in Hollywood during the silent era have disintegrated thanks to the highly flammable and unstable nature of the nitrate film that was used. Many notable exceptions remain of course, classics such as *The Iron Horse* (1924) and *The Vanishing American* (1925), but the fact is only a paltry 200 or so silent movies survive to this day. There remains massive gaps in the early archives of the major studios. Gaps that can never be filled.

The first movie studios were born along America's heavily populated east coast, and it would be a decade or more until they began relocating to Los Angeles where the weather was warmer and sunnier and allowed for year-round production. The western was slow to develop an audience in the early 1900s, lagging behind the more popular early 'romantic melodramas', but by the end of

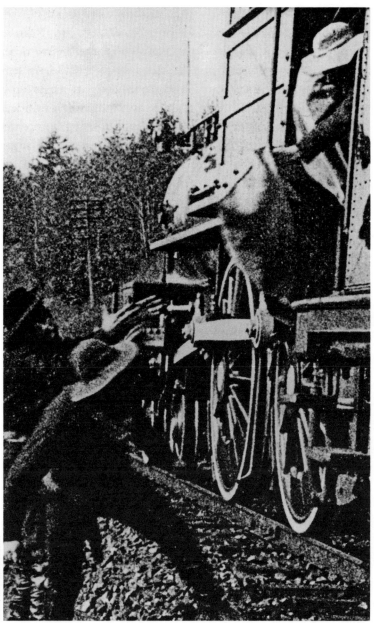

the silent era it had become the industry's dominant genre.

The Great Train Robbery was shot in New York City's Edison Studios, which was at the time the epicentre of America's emerging film industry, and in the preserved wilderness of New Jersey's South Mountain Reservation. An archetypal western tale already familiar to a new generation of movie-goers thanks to dime store novels, travelling wild west shows and stage productions, the film tells the story of a group of bandits who rob a train and are chased on horseback by a hastily assembled posse into a forest, where they are killed in the western's first-ever 'final shootout'.

The film was a milestone in the development of *all* genres thanks mostly to the revolutionary film pioneer Edwin Porter, a former projectionist now in charge of Edison Studios and the country's most influential film maker. Porter gave us film's very first pan-shots (in scenes eight and nine), created the 'dissolve' edit, the process where one scene gradually fades into another, and perfected the technique of 'cross-cutting', allowing the audience to see simultaneous scenes being acted out in various locations despite there being no precedent for such imagery and leaving it to the audience to 'figure out' precisely what it was they were seeing. Composed of fourteen different scenes, Porter infused it all with the one essential ingredient that would be acknowledged by generations of film makers as necessary for any film: a storyline that creates audience involvement via a series of interconnected scenes.

Fresh and new, it owed nothing to the long-established world of the theatre. Vicariously immersing the audience in the thrill of a robbery, it ended with an image that is still eerily confronting today – an innovative world-first close-up of a bandit firing six bullets directly into the darkened theatre at unsuspecting patrons who must have

fairly squirmed in their seats. Never before had there been such a themed approach to movie making, such a richness of moving images and depiction of landscapes. The public couldn't get enough of it.

The Great Train Robbery was inspired by an actual event, the hold-up of the Union Pacific Railroad's #3 train near Table Rock, Wyoming, by Robert Leroy Parker's (aka Butch Cassidy) 'Hole in the Wall' gang on 29 August 1900, a gang who would themselves, be the subject of one of the most beloved films of all time. In the meantime the western, though there was a lot of perfecting still to come, had just been given the best start a genre ever had.

44. *DJANGO* (1966)

When we think of Italian westerns our thoughts invariably turn to Sergio Leone and his epic trilogy of Dollar westerns, of Clint Eastwood and serapes and chewed cigars. But the era of the Italian western did not begin and end with Leone. Puccini's opera *La Fanciulla del West* (*The Girl of the Golden West*), which premiered on stage in 1910, was twice made as a silent film, and then twice as a talkie. Leone's own father Vincenzo made *La Vampira Indiana* in 1913, generally considered to be Italy's first western and Italian film makers also made a number of early Wild Bill Hickok features. The modern era of the spaghetti western (let's put aside the lengthy and rather 'wordy' debate about what precisely the term means) began in the early 1960s with a series of films including *The Magnificent Three* (1963) and *Gunfight at High Noon* (1964) directed by the prolific

Joaquín Luis Romero Hernández Marchent, and a new film from up-and-coming director Sergio Corbucci, *Minnesota Clay* (1964), which was released just two months after the film that triumphantly brought spaghetti westerns to the world, Leone's *A Fistful of Dollars*.

Corbucci began his career as an assistant director in the early 1950s with a reputation of being able to deliver big action sequences despite minimal budgets. When working in Spain with friends and soon-to-be spaghetti western trailblazers Sergio Leone, Enzo Barboni and Duccio Tessari on *The Last Days of Pompeii* in 1959, Corbucci remarked to Leone that the canyons and arid landscapes of northern Spain reminded him of Mexico and the American southwest, and that maybe the region would make a good backdrop for an American-style western someday.

A medium shot of the back of Django's (Franco Nero) head opens proceedings, a clear reference to the very same shot from the Japanese classic *Yojimbo*, only here our dishevelled-looking anti-hero is a former Union soldier, trudging across a barren landscape dragging a coffin with something heavy in it behind him in the dirt. He then enters one of the most depressing, decrepit, shanty-like sets a film crew ever constructed, with a main street Corbucci had ordered be turned into a quagmire, a far cry from the hard-baked towns of Leone's Dollar westerns. This north-of-the-border outpost, caught in a struggle between a red-hooded Ku Klux Klan gang of Confederate-minded racists and a rival mob of gold-crazed Mexicans, is a stand-off that Django is determined to manipulate in the hope of acquiring their gold for himself. But not before he kills as many of the hood-wearing thugs as he can and in the process avenges the death of his wife years earlier at the hands of one of their number, the sadistic Major Jackson.

Yet unlike Leone, Corbucci only wants to indulge in the situations he created rather than bothering to fathom any truths that might lie beneath them. One of the most widely imitated spaghetti westerns of all time, *Django* brought with it a degree of stylisation never before seen in the genre, and a new nihilism with more grit and an unprecedented level of violence. Corbucci's world was that of the anarchist, with the hero and/or anti-hero an alienated and often ragged outsider with questionable moral scruples. His landscapes have no inherent beauty, his characters no emotional depth. Even its flaws are curiously endearing. The scene where Jackson is walking down the town's main street towards the saloon with five men alongside him and yet somehow manages to enter it with considerably more is, I suppose, a shocking bit of continuity. But honestly – does it matter?

In a deliberate departure from everything 'Hollywood', Corbucci never once puts Django on a horse, and the frontier town, normally a bustling, edgy, congested cacophony of traders, horses and wagons, is a virtual ghost town except for a sprinkling of prostitutes, a violin-playing bartender, the spineless Brother Jonathan who collects protection money for the Klansmen, and various other drifters and malcontents. The film's action scenes were cut for maximum, violent impact and its colours enhanced by Corbucci's cameraman Enzo Barboni in an attempt to camouflage what was a very modest budget. But the film's 'hidden' star is without doubt art director Carlo Simi, who created a town filled with smashed windows, boarded-up doors and with fallen tree trunks left to rot in its muddied streets, a feat of design that represents a masterclass in low-budget creativity.

The music was composed by the Argentinian-born Luis Bacalov, who sang the title song that Quentin Tarantino re-uses in his fabulous homage *Django Unchained*, in which

Franco Nero makes a nice cameo as a barfly in a brief scene with Jamie Foxx. Bacalov's opening theme song also contains the most thrilling guitar solo any spaghetti western ever had, as well as 'La Corsa', a piece that begins with a lilting flute prelude that explodes into a riot of brass as Django – hopelessly out-gunned it seems – confronts dozens of Klansmen in the main street only to cut them down in a bloody hail of bullets when he finally lifts the lid on his coffin and reveals its contents: a Gatling gun, which proves very efficient in turning what was a lop-sided shootout into a more level playing field.

In the final scene, Django, his hands crushed under horses' hooves by the Mexicans he initially took sides with, uses an ornamented wooden cross to rest his Colt Peacemaker on before proceeding to kill Jackson and the five remaining Klansmen that surround him. But Django is far from happy, and the film ends on a sombre note. The gold he coveted had sunk to the bottom of a quicksand pit, and with the half-breed prostitute Maria badly injured and himself looking a miserable, tortured figure, there seems every reason to suspect the redemptive note struck by the words of the title song that plays as he trudges off – 'After the showers, the sun will be shining' – will not ring true for him.

Django spawned more than 30 sequels and assorted derivatives, was considered so violent it was refused certification in Great Britain until 1993 (do we have the 'ear-severing' scene to thank for this?), and made stars of Corbucci and of his leading man, Franco Nero. The countless *Django* re-boots read like a who's-who of Italian cinema, including *$10,000 Blood Money* (1966) with Gianni Garko, *Django the Bastard* (1969) with Anthony Steffen, and the rather awful spaghetti western musical *Rita of the West*, which starred the singer Rita Pavone (and included a clever

satirical reference to Django). But it is Corbucci's original blood-spattered masterpiece that we all remember (even though the English dubbing of the print I watched was quite awful), a movie that became a phenomenon in Italy when released in April 1966. It marked the emergence of a style that this much-imitated director would refine in the years to come in the politically charged themes of his sub-genre Mexican 'Zapata-spaghetti' westerns, a final flurry of greatness combining pulp-style action with humour, pathos and politics from one of the western's greatest and most enduring innovators.

43. *THE OUTLAW JOSEY WALES* (1976)

The idea for the movie *The Outlaw Josey Wales* came from the Forrest Carter novel *The Rebel Outlaw: Josey Wales*, later re-published under the title *Gone to Texas*, which was sent to Clint Eastwood's production company, Malpaso, as a 'blind submission' from Whippoorwill Publishing in the early 1970s. It had such a poor cover it sat on Eastwood's desk for two weeks before he read it, but when he did he knew immediately he had the makings of a great picture. Impressed by its pessimistic view of war, how it destroys not only the participants but those people to whom the dead and injured matter, Eastwood purchased the movie rights and brought in writers Sonia Chernus and Philip Kaufman to produce the screenplay and introduce more action. The contribution of Kaufman, who was also hired to direct the picture, was considerable. In his own words, he had 'chosen the cast, picked the locations, determined the look of the film

and the wardrobe'. His screen adaptation contemporised the language, turning 'hosses' into 'horses' (so Eastwood, according to one story, wouldn't have to memorise the dated speech and would need less rehearsal time), and gave a much harder edge to the role of the red legs, ratcheting up the harrowing scene of the killing of Wales' family and the red legs' relentless pursuit of Wales throughout the remainder of the film. The relationship between Eastwood and Kaufman, however, which began with such promise, would not end well. Kaufman was fired by Eastwood just two weeks into filming after a series of creative disagreements. Kaufman retained the screenwriting credit, but Clint Eastwood was now the film's director.

When Missouri farmer Josey Wales' family is slaughtered by a sadistic Union officer during the Civil War, he joins a group of Confederate fighters who manage to avoid capture and are granted amnesty at war's end. But the 'amnesty' proves a trap, and Wales' comrades are murdered. Wales, who refused to join the amnesty, is now an outlaw with a $5,000 price on his head – and being hunted by the same man who killed his family. Up to this point Wales exhibits many of the characteristics of the Man With No Name – speaking few words, living by an unspoken code, a man who keeps to himself. As he drifts from place to place, however, his demeanour begins to change as he comes to know a collection of similarly marginalised souls who go on to become his friends, including the ageing Comanche Lone Watie (Chief Dan George), the young Navajo girl Little Moonlight (Geraldine Keams), all that is left of a Kansas family who met with disaster in their search for riches. Wales is forced to connect with those around him, and in spite of the loss of his family becomes determined to live a useful and meaningful life, which he again begins to embrace.

Eastwood wanted the treatment of Native Americans to be sensitively written and portrayed in this film. The scene where Lone Watie sneaks up behind Wales, puts a gun to *his* head, then boasts: 'Only an Indian can do something like this' – is funny enough and made me laugh out loud, but then was made even funnier when Little Moonlight, in turn, sneaks up on Lone Watie and puts a gun to his head! There is real humour in the Lone Watie character ('I didn't surrender, but they took my horse and made him surrender'), which is a breath of fresh air because even movies that tried to humanise Native Americans over the years, movies such as *Broken Arrow*, seemed intent on tackling it from every direction *except* bothering to show they also possessed a sense of humour.

Clint Eastwood had been a movie star for well over ten years when he directed this, his fifth feature film. He began in television with *Rawhide* at a time when the western was deeply entrenched in every living room in America, and came to *Josey Wales* at a time when the genre was all but extinct. It was a brave move – on the one hand, trying to once again interpret all of the conventions of the past, but also finding a new way forward in the study of violence and how its application alters us. The drifter of Sergio Leone's 'Dollar westerns', which he was more or less pre-destined to bring into this film, was no more. Here he was, a farmer happy to plough his fields, a man with a family, and with a name too.

At last, the Man With No Name had been stripped of his anonymity and given a story.

42. *THE SEARCHERS* (1956)

In May 1836, Cynthia Ann Parker was around nine years old (her precise birth year is unknown) when she and four others were abducted from their settlement of Fort Parker in north-central Texas in a brutal, murderous assault by several hundred Kiowa, Caddo and Comanche raiders. Several members of her own family were killed in the raid, including her uncle, Elder John Parker. Over the next six years, the four settlers taken with Cynthia were released, but she was not and over time she integrated into the tribe and became a Comanche woman in every sense. She lived with her adoptive family for 25 years, was raised by a Comanche couple, married a Comanche warrior, and had three children whom she loved. In 1860 a group of Texas Rangers attacked her Indian camp on a tributary of the Pease River, mortally wounded her husband Nocona, and to their astonishment found a woman who had blue eyes, holding her infant daughter. Recognised as a white woman, Cynthia – whose Comanche name was Naduah ('She carries herself with grace') – was taken into white society and even given an annual grant of $100 as well as a plot of land. But she never integrated back into white society. She attempted several escapes, but with the passing of her two sons, and then the death of her daughter from influenza in 1864, Naduah fell into a deep depression, refused to eat and died in 1870 at the age of 43.

Alan Le May's book *The Searchers* was published in 1954, and there is some conjecture as to whether or not his account is actually inspired by the Parker abduction. Some say the story of Millie Durgan, captured by Kiowas when only eighteen months old in 1864, could have provided the spark,

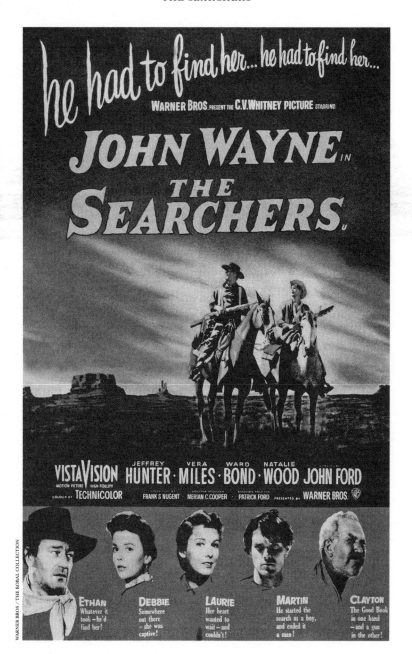

although the fact Le May visited a family descendant of Cynthia Anne Parker, Ben Parker, in Elkhart, Texas, suggests it is the Parker story that served as its likely starting point. Yet while there are at least threads linking the abduction to Le May's work, the old problem of western-era frontier stories being effortlessly transformed into legends persists, and Le May's book was always going to struggle separating fact from fiction. And as for the film? Well, let's just say facts were never going to get in the way of a Hollywood movie making the most of one of the west's classic captivity tales. When Ford turned not to Le May but to his friend Frank Nugent to write the screenplay, then decided to shoot it in his beloved Monument Valley instead of Texas where the events occurred, that was all Le May needed to decide to stay well away from the fictional rendering that was coming.

Directed by John Ford, *The Searchers* starred John Wayne as Ethan Edwards, a former Civil War (Confederate) soldier on a search for his niece Debbie (Natalie Wood), who had been abducted by the Comanche after a raid on a Texas settlement. Whenever the film is talked about, it's always the psychology of Ethan Edwards that generates the most analysis. This man is no hero. He hates the Comanches, to the point of shooting out a Comanche's eyes so he'll be unable to enter the spirit world, and shooting bison simply so he can deprive the Comanche of food. His hatred of interracial mingling is the driving force behind everything that he does, what takes him forward over the seven years of his search. Yet for a film as lauded as it is, it has an uncomfortable degree of static awkwardness about it.

The Searchers received only lukewarm praise when it was released, but is now often thought of as a classic. Personally I can't see why luminaries including Martin Scorsese rate it quite as highly as they do. Edwards seems to have learned

nothing from war, leaving the chaos and brutality of the Civil War only to revel in his hatred of Indians on his interminable quest to locate Debbie; only not to save her, but to *kill* her for having become contaminated, first through her physical contact then through her sexual contact with the Comanche. It comes close to not making any real sense, the fact that after seven years spent searching for his niece Edwards still has the impulse to kill her within him when he eventually finds her. Could it have been a veiled commentary on white/black relations? Its racial overtones certainly were not lost on those in the African-American community, at a time when it was all but impossible to make a film about African-American/white intermarrying, but perhaps it could be done through the prism of Native America.

Despite the shortcomings in its plot, there's still enough here to set it apart. The idea that settlers could be cold, heartless, even brutal – how many westerns depicted an attack on an Indian village in which Indian women and children are killed? – was ground-breaking. And of course there's the moment, as contradictory as it is, when Edwards, after having scalped the Indian Chief Scar (Henry Brandon), cannot in the end bring himself to kill his niece but instead scoops her up in his arms, lifts her up above him and then drops her down to cradle her and then speaks the first tender words he says in the entire film: 'Let's go home, Debbie'. This astonishing change of heart becomes one of the great 'What the &*^%$?' moments in cinema. Had the scalping of Scar purged his vengeful heart? Or was this merely one of the all-time classic cave-ins to the Hollywood mantra of the 'happy ending'? Or if that's too cliché to swallow, better to call it an invitation to ponder this uneven film's many ambiguities.

41. *THE SHOOTIST* (1976)

In 1997 I was in the midst of a five-week road trip across America that I'd spent several torturous weeks whittling down from 500 or more destinations to a few dozen. A place had to be special to survive a dispassionate cull like that. But 224 South Second Street in the small town of Winterset, Iowa, the birthplace of a man whose walk and gait I was as familiar with while growing up as a teenager in the 1970s as I was my own father's, was never in doubt. The birthplace of John Wayne is a modest, 1880s four-room clapboard house that still has its original floorboards, and still just the one bedroom: the room where *he* was born. It also housed a tiny but impressive collection of Wayne movie memorabilia – including to my delight the 'blood-stained' shirt he wore in that last memorable gunfight of his career at the close of one of my favourite John Wayne films of all time – *The Shootist.*

The year was 1901, the place Carson City, Nevada. Queen Victoria was dead, electricity and paved streets and sewage systems were all on their way, and men like J.B. Books had, in Marshal Thibido's (Harry Morgan) words, 'plain plumb … outlived your time'. The curtain was closing on the era of plains drifting gunmen, their 'wild' west shrinking under the weight of every new metre of rail line laid. After receiving a dire prognosis for a stomach complaint from the town's Doc Hostetler (James Stewart), Books chooses to stay in Carson City and end his days there. But days of extreme pain lay ahead. J.B. Books had cancer. Doc Hostetler tells him: 'I would not die a death like the one I just described. Not if I had your courage'.

THE SHOOTIST

The presence in town of three old protagonists – Cobb (Bill McKinney), Pulford (Hugh O'Brian) and Sweeney (Richard Boone), who would meet Books in the Metropole Saloon for a final reckoning, meant Books need not worry about a slow, painful death. He found lodging in a boarding house run by Bond Rogers (Lauren Bacall) and her son Gillom (Ron Howard), and the relationship Books develops with the young and impressionable Gillom becomes one of the film's cornerstones. But events are quick to evolve, with the film taking place over the course of a single week, beginning with Books' arrival in Carson City and ending with the shootout that would claim his life.

Wayne and the film's director Don Siegel did not always see eye to eye. During filming of the gunfight in the Metropole, Wayne was taken to hospital and while absent Siegel continued to film the scene using a body double to stand in for Wayne's character. At one point Siegel had Books shooting one of his protagonists, Jack Pulford, in the back. When Wayne learned that Siegel had his double shoot someone in the back, Wayne returned to the Burbank Studios and insisted Siegel reshoot the scene. 'I've never shot a man in the back my entire career', Wayne later recalled in an interview. (He actually did, in *The Searchers*, but let's not let the truth get in the way of a good quote!)

A low-budget film that did poorly at the box office, *The Shootist* is now generally regarded as one of Wayne's finest films, a stand-out western in a decade that was a poor one for the genre. I always consider the final shootout in the Metropole to be one of the finest examples of a choreographed gunfight I've ever seen, while the presence of Lauren Bacall and James Stewart, who brought with them their own long associations with Wayne, gave their scenes with him a deep resonance, even poignancy. Yet the film adroitly avoids sentimentality

and is directed with great sensitivity by Siegel, a surprising accomplishment perhaps, given this was the man who gave us *Dirty Harry*. Wayne's performance was intimate, bordering on the confessional, and throughout it all you could sense just how aware of his legacy he was – over 250 films – summed up in a fitting homage to the man who, more than any other, defined and embodied all that was fit to print about the white man's subjugation of the American west.

40. *BROKEN ARROW* (1950)

Set in Arizona's Apache territory in 1870, *Broken Arrow* was one of the first Hollywood movies to attempt to sympathetically portray the lives and traditions of Native Americans. Tom Jeffords (James Stewart) finds an Apache boy who has been injured by gunfire and heals his wounds. Some Apache warriors then arrive but see that he has tended to the boy and so choose to allow Jeffords to live. When a group of prospectors come on the scene, however, the Apaches kill them as Jeffords watches on helplessly after they tie him to a tree. Jeffords feels for the Apaches, whose lands are being swallowed up by westward expansion, and so learns the Apache language and customs and becomes a mediator between them and his own people, whose mail couriers have been killed by Cochise's men in the past while passing through Apache territory. Jeffords convinces Cochise (Jeff Chandler) that the letters the man carry are like their own smoke signals, and they mark their agreement with a traditional broken arrow. Jeffords then falls in love with an Apache girl (Debra Paget) and

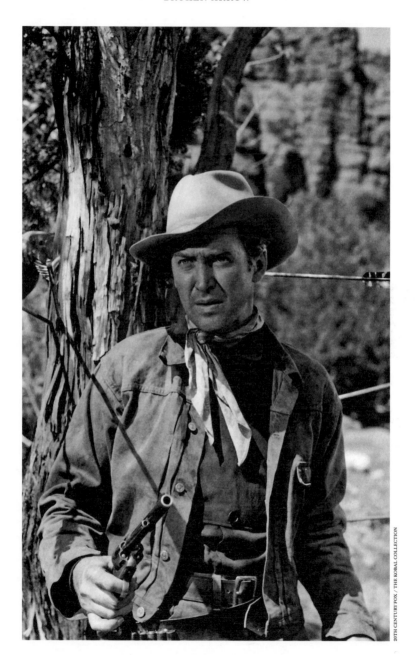

marries her – itself a new concept for Hollywood. But of course the new accord with the mail service brokered by Jeffords fails to hold after a group of Apaches, led by the rebellious Geronimo, ambushes a stagecoach, which leads to a gunfight in which Jeffords' wife, Sonseeahray, is killed. Cochise accepts responsibility for Geronimo's actions, and forbids Jeffords to seek revenge. The killing, Cochise insists, must stop. Jeffords then rides off, taking the memory of his beloved wife with him.

The Apaches of *Broken Arrow* were not tomahawk-wielding, screaming bareback-riding savages, they were real people. Although the film could have been a lot more respectful of Native American culture (Cochise and Sonseeahray were, after all, played by white actors), it was for its time a very genuine and laudable attempt to make a film that didn't simply follow accepted Hollywood norms. In fact, despite being white, Jeff Chandler became something of a drawcard for African-Americans in the 1950s when his portrayal of Cochise was seen as a genuine effort to attempt to empathise with the struggles of America's various minorities. The fact Cochise was 65 years old in 1870, and Chandler a youthful looking 30, hardly mattered.

The film was written by playwright Albert Maltz, one of the infamous Hollywood Ten who was sent to prison in 1950 for refusing to testify to the US Congress about his alleged links to the US Communist Party. Maltz was blacklisted and his name struck from the credits of *Broken Arrow*, which saw fellow screenwriter Michael Blankfort's name added in his place. (It was Blankfort's name that was read out as the winner of the 1951 Writer's Guild of America Award for the year's best-written western, though Maltz later received due recognition as the film's sole screenwriter.) The character of Jeffords, while a long way off undermining traditional

notions of what made a typical pioneer, certainly is a lot more 'peaceable' and questioning of the concept of 'Manifest Destiny' that drove Americans westward to conquer all that came before them.

Broken Arrow was directed by the largely unheralded Delmer Daves, whose films were gaining a reputation for being 'genre-defying'. Daves got his first job in Hollywood in 1923 as a prop boy in the James Cruze silent western *The Covered Wagon*, still considered to be the first western 'epic', which told the story of a wagon train's crossing of the Platte River Valley in 1848. *Broken Arrow* benefited from Daves becoming so impressed with the Native Americans who worked on *The Covered Wagon* that he gave up a promising career in law and went and lived with the Hopi and Navajo Indians in Arizona. He later returned to Hollywood, where he began as a screenwriter before directing a few low-budget Second World War films and spending most of the 1950s directing westerns – including the original *3:10 to Yuma*.

I like the effort Daves made to create a western that was sympathetic to the Native Americans he so respected. If you can leave any sophisticated, enlightened 21st-century thoughts on racism at the door and approach this film with a 1950s mentality, you'll discover a brave film that attempted to chart a new course for the genre, presenting a new vision for a quieter, a less 'wild' west. *Broken Arrow* is a progressive film that suggests ways forward for a divided and deeply prejudiced nation, and with the presence of James Stewart, one of Hollywood's most-loved and respected stars, providing a central character able to take audiences along with him – and into Daves' uncharted world of 'radical traditionalism'.

39. *SHANE* (1953)

In the late 1880s, a lone, buckskin-clad gunman (Alan Ladd) rides through the landscape surrounding Wyoming's Grand Teton mountain range. It was a time when the Great Plains were seeing a series of territory quarrels between established cattle barons, who came out west in the wake of the Homestead Act and now owned vast tracts of grazing land, and an influx of smaller homesteaders staking new claims on often disputed areas. It was the time of the 'Johnson County War', when cattlemen used barbed wire, a new invention patented in 1874, to mark their boundaries and protect their access to water, and paid hired guns to chase out the settlers they saw as 'rustlers'. But whether cattleman or homesteader, the effect was the same. The wild west was being divided up, and the open range was becoming a thing of the past.

The gunman, Shane, enters the homestead of Joe Starrett (Van Heflin), his wife Marian (Jean Arthur) and their young son Joey (Brandon deWilde). The young boy is drawn to Shane, and to his gun, all the more because his own parents do not want guns to play any part in their boy's upbringing. Sadly though, the time for guns is fast approaching. An unscrupulous cattle baron, Rufus Ryker (Emile Meyer), wants to seize the Starrett's land, and employs the psychopathic gunman Jack Wilson (Jack Palance) to intimidate and do whatever is necessary to get the Starrett family off their land. After a raucous fight in the saloon, where Shane and Joe Starrett fight back to back against a room full of cowboys, the inevitable confrontation between Shane and Wilson looms ever closer. The final shootout that occurs also

includes Ryker and his brother Morgan (John Dierkes). 'I hear that you're a low-down Yankee liar', Shane tells Wilson, repeating Wilson's own words to Frank Torrey (Elisha Cook Jr), a homesteader he murdered earlier in the film. 'Prove it', Wilson says. Shane then outdraws him and kills him, then shoots and kills Ryker, and his brother Morgan as well. Joey witnesses the entire showdown. In the wake of the gunfight Shane knows it is time for him to move on. The valley has been freed of guns and intimidation, the land returned to the homesteaders. The scene where Shane says farewell to Joey and the boy yells out in vain 'Shane! Come back Shane!' is one of the most famous and heart-wrenching moments in the history of American cinema.

How a person views *Shane* I suspect depends on whether or not they have children. I know that when I saw it as a youngster, while I enjoyed it, I had nothing like the emotional response to the relationship between Joey and his parents or to that moving final scene than I did when I watched it again recently, now a father of two young boys. *Shane* is an example of how old, familiar scenes can be given new life and fresh perspective when seen through the eyes of a child. Director George Stevens provides an interesting subplot with Marian's attraction to the handsome gunman, but what is really going on here is a clever piece of deception – read between the lines and this western isn't the traditional fare it appears to be. Its heroes are far from over-the-top heroic, while the lives of its ranchers are not one-dimensional and unimportant but instead possess all the layers of complexity that you find in families everywhere. Even the villain Jack Wilson is given a great speech halfway into the film where he attempts to justify his behaviour, and even though there was no justifying what he has done, at least the audience

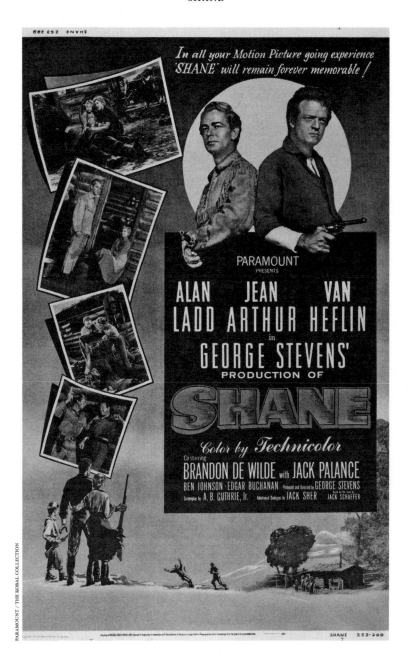

61

was given an insight into his motivations. He was made a little more human.

The Oscar-winning cinematography of Loyal Griggs takes full advantage of the inspiring Grand Teton massif and the new 'flat widescreen' format that the studio, Paramount, had just perfected. Griggs, who entered the world of film making in the 1920s, had only been 'promoted' to the job of director of photography in 1951, and what he gave us was one of the first really expansive views of the west in all its colour and glory. Another innovation was Stevens' idea of attaching a wire to the back of an actor about to be shot, so the wire would pull the actor back, simulating the effect of being hit.

The film did have its fair share of rather corny dialogue, however; and I'll always wonder how the character of Shane might have been played if the role had instead gone to Montgomery Clift, whom Stevens had originally cast in the role but who was unavailable. One scene, where Ladd practises his aim with Joey looking on, had to be shot over a hundred times, and Jack Palance, who didn't much like horses, had some footage of him dismounting a horse reversed so it looked like he was getting on, a technique Stevens had used before working with comedians Stan Laurel and Oliver Hardy.

Completed in 1951 but not released until 1953 because of the enormous amount of editing Stevens insisted on doing (together with editors William Hornbeck and Tom McAdoo), *Shane* is an enduring example of how the world, when seen through the eyes of a child, isn't such a bad place after all.

38. *DEAD MAN* (1995)

If you'd been born the son of a film critic and spent most of your formative years in the dark watching B-movies and pursued your love of film into adulthood, and if you'd been blessed with a very genuine talent, chances are you'd likely end up one day ensconced somewhere within the environs of the film industry. That's what happened to Jim Jarmusch. He went from his home in Akron, Ohio, to New York and then to Paris, where he spent a year soaking up the vestiges of French New Wave cinema before returning to New York and enrolling in Columbia University, only to find English Literature was not, after all, his first love. So he moved to New York University's Tisch School of the Arts, where he found himself a job assisting the great Nicholas Ray, the director responsible for, among other classics, *Johnny Guitar* and *Rebel Without a Cause*. Ray helped Jarmusch fund his first short film, the overlooked but critically acclaimed *Permanent Vacation* (1980), but it was his second short, *Stranger Than Paradise* (1984), that made people sit up and really take notice. A string of fine low-budget, arthouse films followed and then, right out of nowhere in the western-less void that was the mid-1990s, Jim Jarmusch decided the time was right to make a western. And not just any western, but a black-and-white one, an astonishing decision in itself because studios don't like financing films they consider might perform poorly at the box office, and nothing gives that impression quite like the decision to abandon colour. Not to mention the fact the last major black-and-white western made in the USA was *The Man Who Shot Liberty Valance* – in 1963!

Dead Man tells the story of William Blake (Johnny Depp),

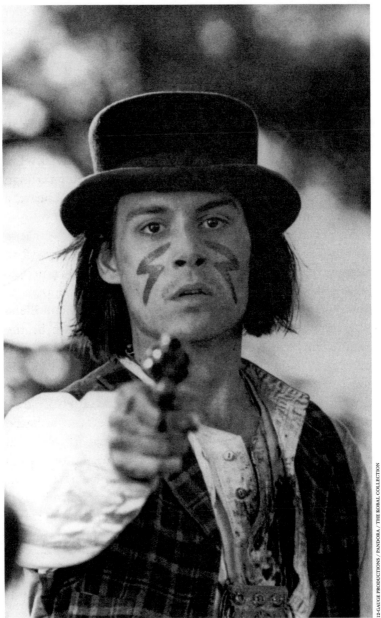

a just-orphaned accountant from Cleveland who comes out west to apply for a job in the frontier town of Machine. On arrival, he is told by the owner of the metal fabrication factory John Dickinson (Robert Mitchum) that the job has been taken. Upset that he'd made a very long train journey for nothing, Blake enters a tavern and spends the night with former prostitute Thel Russell (Mili Avital), which leads to a fight with her former lover, John Dickinson's son Charlie (Gabriel Byrne), whom Blake shoots through the neck – but not before he himself is shot, the bullet first passing through Thel and then lodging uncomfortably close to his heart, a mortal wound that would eventually kill him.

Now on the run and with three very unsavoury-looking bounty hunters on his trail, Blake meets a Native American named Nobody (Gary Farmer), shunned by his own people because of his western education and who just happens to possess a liking for the poetry of Englishman William Blake (what are the chances?). Nobody believes Blake to be the great man's lost spirit, and vows to be his guide in what becomes a rather protracted passage into the realm of the spirits. Blake certainly seems to be channelling something, though, morphing as he does from someone who has barely ever handled a gun and needing three bullets to kill Charlie Dickinson who was standing just a few metres away, then with no practice becoming so adept with a gun he's able to kill two US marshals, one of whom already has his gun drawn! Still, if you can believe a Native American (Nobody) was captured by the British, taken to England, put on show there, became familiar with (of all things) the poetry of William Blake, and then returned to America where he then meets a wanderer named none other than William Blake, then really you shouldn't have a problem with Blake suddenly becoming an expert marksman.

The bounty hunters, meanwhile, are now down to one man after Cole Wilson (Lance Henriksen) guns down his two accomplices and then eats one of them before continuing his pursuit, while Nobody and Blake keep a step ahead until they reach an Indian settlement where Nobody prepares a canoe to take the dying Blake out to sea and on to eternity. Wilson then turns up, however, and there is gunfire between him and Nobody. But we do not see its outcome. Just another question mark Jarmusch is happy to leave dangling as Blake, now at peace in his canoe, slowly drifts away.

Jarmusch, who specialises in blurring the distinction between the experimental and the mainstream, considers the western (a little disparagingly perhaps) as a kind of 'fantasy world', a safe place that America has always gone to in order to process its ideologies and myths. Native Americans were rarely ever made real in them, a reason why Jarmusch's own impeccable research into their customs seems so fresh and authentic here, even to the point of including non-subtitled conversations. *Dead Man* in fact was so enthusiastically embraced by Native America that when invited to a Native American film festival in New Mexico, Jarmusch was the only white man promoted on a series of posters in the venue's foyer, and in a ceremony there was given the name of Silent Snow Wolf.

Dead Man defies categorising. It has a very passive central character, itself a turning-on-the-head of the usual western conventions. It is a little hallucinatory, with an unnatural rhythm that can make it hard going if you approach it with too many preconceived ideas about how a western should look and feel – so better to leave all that at the door. There are a multitude of fade-outs, narrative-driving cameos and a memorable electric guitar score by Neil Young. I understood all of that, but I couldn't see why the insistence on the

link to the great poet. That was, until I heard an interview with Jarmusch who explained that on reading Blake one day he found his writing seemed to contain a wealth of Native American aphorisms, stuff like: 'Expect poison in standing water'. To Jarmusch it seemed Blake had a string of connections to Native American beliefs. 'I really believe', Jarmusch said, 'that Blake wanted to be a part of it all'. Ummm, ok then.

The journey of Nobody and Blake is a mystical one, with no apparent pattern or purpose other than to deliver Blake to his canoe for his final voyage out to sea, into the unseen realm of the spirits. It is a brave film in its disregard of convention, with its off-beat sets and its wilderness filled with misfits and oddballs (there's barely a white man anywhere with a shred of merit) that give the film an apocalyptic, end-of-world feel. You expect zombies to come out of its dark recesses. In the end it's a film that can stand shoulder-to-shoulder against any classic western you care to put it up with, a film with a thin thread of something bordering on incoherence that seems like a deliberate dare, inviting criticism while defying analysis.

So if you're like me and had to watch it twice to make sense of it once, that's ok too. Robby Müller's exquisite black-and-white photography, some of the finest a western movie has ever been fortunate enough to have, is enough on its own to guarantee your 121 minutes will have been time well spent. Jarmusch and Müller worked with no storyboards or shot lists. Müller prefers to trust his instincts and intuition, always thinking on his feet, adjusting to the prevailing light, changing dialogue to accommodate the rain if it's raining instead of waiting till the rain stops. On *Dead Man* their scouts found all of the typical western landscapes, only to have Müller wanting to turn his back on them and film in the

opposite direction, towards a rock or something else equally uninspiring. Great landscapes like these have been seen a thousand times before; let's show the audience something different. And that's why *Dead Man* is so hypnotic. It might be a 'slow movie', in calculated opposition to the 'cinema of action', but it shows with consummate flair that the western is as capable as it ever was of taking audiences where no western has gone before.

37. *3:10 TO YUMA* (2007)

Elmore Leonard was born in New Orleans in 1925, but spent most of his early years in Detroit. After serving with the US Navy Seabees in the Second World War, he turned his hand to writing short stories, and later pulp western novels. In 1953, *Dime Western Magazine* published a Leonard pulp story titled 'Three-Ten to Yuma', which ran to about twenty pages. It was the story of Dan Evans, a struggling rancher and one-legged veteran of the Civil War who, while out riding with his sons, witnesses the outlaw Ben Wade and his gang robbing a stagecoach. Later Evans agrees to join a posse (he could use the money to pay off some of his debts) that has been gathered to deliver the now captured and handcuffed Wade to the town of Contention, a hazardous journey through Indian territory. From there the 3:10 train, which carries its own prison cell, will take Wade to Yuma for his trial and, it is assumed, his eventual hanging.

A remake of the very good 1957 version of Leonard's story, which had a 'clock ticking down' motif every bit as effective as the famous example in *High Noon* and starred Glenn Ford

as Ben Wade and Van Heflin as Dan Evans, this version is an even grander achievement. Russell Crowe now fills Wade's boots and Christian Bale plays Evans, and together they light up the screen with their intensity. The character of the outlaw Wade is straightforward and uncomplicated, but that of Evans less so: he is a man who needs to complete the ride and get Wade to Contention so he can collect his payment, and a man who wants to show his son William (Logan Lerman) that he is capable of being more than just a rancher. He would also welcome the chance to show he is unafraid of the situation, as his only action in the Civil War was a retreat. There is pride attached to what he is doing, and there are echoes of the loneliness felt by *High Noon*'s Marshal Will Kane in the figure of Evans. The villainous Wade, on the other hand, played with aplomb and a disturbing level of casual cruelty by Crowe, makes for equally interesting viewing and once again confirms that old western adage that the stronger the bad guy, the better the movie.

All the ingredients are here that make for a great western – there are windswept towns, open prairies, rocky landscapes, spineless lawmen, young men on the cusp of manhood wanting to prove themselves, and the relationship of father with son and the angst it produces in Evans, who is being cleverly manipulated by the alternately charming and ruthless Wade. When Wade's gang members attack a decoy wagon and learn that Wade has been delivered to Contention, they make their way there and proceed to offer money to anyone willing to assist them in freeing him, which results in the entire posse charged with taking Wade to the train at Contention, with the exception of Evans, abandoning their prisoner and fleeing. When Evans confesses to Wade his own personal circumstances, that he only needs to deliver Wade to the train to collect his payment, Wade agrees to board the

train. Evans, however, is shot by Charlie Prince (Ben Foster), one of Wade's gang, and Wade is so enraged he kills his gang members before riding the train, which is closely followed by his horse, until it is out of sight. Whether or not Evans dies is left ambiguous; what is certain though is that Wade has escaped his captors.

3:10 to Yuma has a real freshness to it, as though director James Mangold had never seen a western except for the 1957 original he was now revisiting, and so could approach it with new eyes. Some suggested this film was so good it might single-handedly reignite the genre, which is nonsense of course as it will never go away. I recall the feeling when I saw it that no matter how many times the western might be written off and consigned to the celluloid dustbin, there will always be films like *3:10 to Yuma* that come along and remind us that any stories that are told in contemporary dramas can be just as effectively told against a backdrop of the old west.

36. *WAGON MASTER* (1950)

There are plenty of reasons why a good film is overlooked and is slow to make an impact with audiences or critics. It might have a tiny budget, or it might lack big-name stars. It might not appear at first glance to have a compelling storyline, or the action-packed sequences of its more moneyed-up competitors. But not all films are geared towards making a big splash with the public. Some have been personal projects close to the heart, where a director with sufficient influence and a big reputation might push to produce a film for himself,

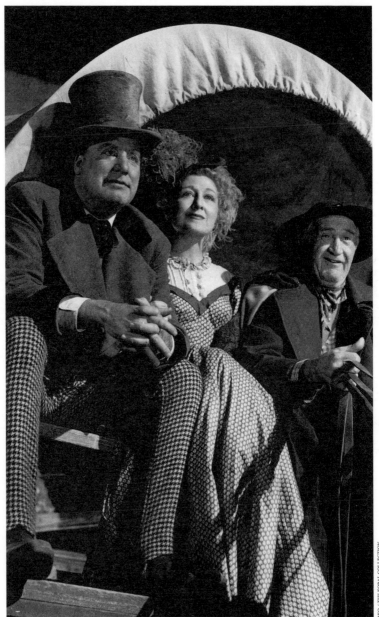

to satisfy his own inner workings, and just make it happen. In 1949 that's exactly what the great director John Ford did when he began to set the wheels in motion for *Wagon Master*, a film about a Mormon wagon train on its journey through Utah to the remote San Juan Valley, an idea he first began to entertain the year before while working alongside Mormon extras in *She Wore a Yellow Ribbon*. As if to underscore just how much of a personal film it was, Ford's son Patrick co-wrote the screenplay with Frank Nugent, the former *New York Times* film-reviewer-turned-screenwriter. The result, as far as the man who gave us *Drums Along The Mohawk* and *Stagecoach* was concerned, turned out to be exactly as he'd envisioned. '*Wagon Master*', he would later say when looking back over his career, 'came closest to what I had hoped to achieve. It was the purest and simplest western I have made'.

It begins with a nice piece of innovation, the credits only coming *after* a prelude that sets up the outlaw Clegg brothers as the film's protagonists. Using several of the plot elements from Henry Hathaway's *Brigham Young* a decade earlier, *Wagon Master* is a story of laid-back simplicity and unpretentious religious purity. The year is 1879 and Elder Wiggs (Ward Bond) and his fellow Mormons are in the Utah town of Crystal City on their way to the San Juan Valley, where they plan to start a new life far from the religious persecution that has been dogging them. Needing a wagon master to lead them the rest of the way through a harsh and unfamiliar desert landscape, they hire horse traders Travis Blue (Ben Johnson) and Sandy Owens (Harry Carey Jr). On their way, they encounter a 'medicine show' (a troupe of peddlers offering a variety of usually bogus 'miracle cures', a not uncommon sight in 19th-century America) who had been forced to drink one of their own 'elixirs' because they'd run out of water. The inevitable romantic entanglements

soon begin to develop, in the form of a growing attachment between Blue and Denver (Joanne Dru), a sensual, complex girl from the medicine show, and between Owens and Sister Prudence (Kathleen O'Malley). And then of course the outlaw Clegg family arrive, led by Shiloh Clegg (Charles Kemper), having been pursued by a Crystal City posse and who join the train until a final confrontation sees their demise, with Blue symbolically throwing his gun away when the final shootout is done.

There really isn't much of a plot, and the film is missing the usual Ford big-name stars, but that is just how the director wanted it. Not having a John Wayne or a Henry Fonda is a good way to keep costs down, and anyway an ensemble cast made it easier to focus on the nature of 'community', the fact no one person outshines or in any way dominates those around them. It's a perfect atmosphere to develop what is for me the nicest aspect of this charming film – the way Blue and Owens become integrated into the Mormon community over the course of the journey, the way they come upon the realisation that there might be something for them at the end of the trail, too.

Wagon Master was a chance for Ford to dwell on and dissect one of his favourite themes, the creation and importance of community, and represents a refreshing change of pace for a genre where so much is said at the point of a gun. Filmed just four years after the end of the Second World War, none of the Mormons have firearms, Travis Blue says he's only ever 'shot at snakes', and Owen says he's never shot anyone – ever. There is an overt streak of pacifism here. Punctuated by ballads, hymns and sporadic outbursts of song and dance, it is a western bordering on a musical, but is ultimately a tale of redemption, of how two hardened cowboys come to realise the 'softer' side of their natures and who, presumably,

will go on to become husbands (Blue to Denver, Owens to Prudence) and eventually fathers, and thus join Ford's impressive list of family men – Gil Martin in *Drums Along the Mohawk* and Martin Pawley in *The Searchers* – a reminder that the west was settled not by gunmen and bandits but mostly by families, by ordinary people of faith.

35. *THE NAKED SPUR* (1953)

The Naked Spur was the third in a five-film collaboration between director Anthony Mann and actor James Stewart, and is generally thought to have been their finest. It tells the story of Howard Kemp (Stewart), an embittered former rancher whose farm was sold off by his unfaithful fiancée while he was off fighting in the Civil War. Now a bounty hunter, Kemp is determined to buy back his farm with the $5,000 reward for bringing in the notorious Ben Vandergroat (Robert Ryan), wanted for bank robbery and the killing of a marshal in Abilene, Kansas. Along the way Kemp meets up with luckless prospector Jesse Tate (Millard Mitchell) and former army veterinarian Roy Anderson (Ralph Meeker), both of whom insist on sharing the reward, which only increases Kemp's own resentments. Finally there is Vandergroat's attractive travelling companion, Lina Patch (Janet Leigh), the daughter of Vandergroat's dead partner.

Shot at high elevations around Durango in Colorado's Rocky Mountains, *Variety* thought the movie might be 'too raw and brutal for some theatregoers', and certainly the dependable and ever-present morality of the old black-and-white westerns is nowhere to be seen here. Allusions to the

darker side of the cowboy character that were never more than glimpsed for decades were familiar dwelling places for Mann. Kemp is an anti-hero, the James Stewart of Frank Capra's *It's A Wonderful Life* now a conflicted and bitter man walking the line between decency and debauchery as he descends to the level of ruthless bounty hunter, hauling a dead man out of the wilderness before deciding – only in the film's final scene at the behest of Lina – to give him a decent burial, and ride off to begin a new life with her in California.

The film is a taut psychological thrill ride, with the rivalry and physical violence that gradually emerges between Kemp, Tate and Anderson over the reward money highlighting their individual weaknesses. It shows too that the normally affable Stewart can act 'crazy' as well as anyone in Hollywood. I saw this film as a teenager after being brought up watching Stewart exhibit his good-guy persona in everything from *It's a Wonderful Life*, the endearing *Harvey*, and *Flight of the Phoenix*. Watching *The Naked Spur* demolished this cherished legacy of decency and at times made me squirm, every bit as much as seeing Henry Fonda kill a young boy in *Once Upon a Time in the West*. But that's what made Mann the great director he was, always looking for ways to overturn past conventions, always looking for conflict, always looking to make us squirm. The fact he was pigeon-holed as a 'genre director' by critics is hard to understand. His collaborations with cinematographer John Alton on *T-Men* (1947) and *Raw Deal* (1948) are considered masterpieces of film noir, and the transplanting of noir characters into the old west just another example of Mann experimenting with the established ways of doing things.

The five central characters dominate almost the entire movie. Despite having an early action scene where they are attacked by a group of Indians, it is really a dialogue-driven

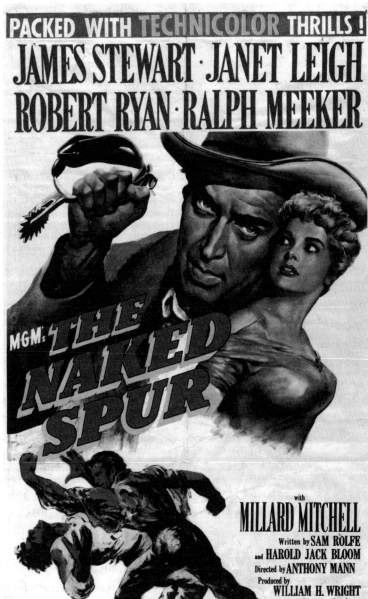

masterpiece, pushed forward by the villain Vandergroat (a typical Mann villain who is also the most likeable character in the film). He attempts to divide and manipulate the others to his own advantage, all the while grinning and cackling with obvious delight, revelling in his villainy, and managing to exert control and influence over the others even when his wrists are tied. The more the male leads shed their morality, the more Lina Patch comes to resemble civilised society from which they are so detached.

The use of a changing landscape to mirror a character's internal psychology was always a tell-tale Mann device, and in the case of Kemp was achieved by using increasingly darkening backgrounds, dense rocky terrain that becomes ever rockier, and the power of the river rapids in the final scenes to reflect his deteriorating psychosis. Every new twist in the trails through this mountainous terrain adds complexity to Kemp's already tortured psyche. Mann was not a big fan of the Monument Valley landscapes of John Ford, instead preferring to see the west as more than just deserts and buttes. 'I wanted to show the mountains, the waterfalls, the forested areas, the snowy summits – in short, to rediscover the whole Daniel Boone atmosphere'. The emotive depth he brings through the use of landscape, and the almost self-perpetuating movement of his characters through it, even the way he uses the camera in *The Naked Spur* to isolate the characters in their various switching of allegiances, makes it not unreasonable to consider Anthony Mann (whom Jean-Luc Godard once famously referred to as 'Supermann') as the era's pre-eminent director of westerns, his films a series of compelling studies as to how good men can be led to abandon honour and decency, thus paving the way for the bloody revisionist westerns of the 1960s.

34. *THE SALVATION* (2014)

Never mind the fact that the director of the Danish film *The Salvation*, Kristian Levring, couldn't afford to film in the American southwest because of his limited budget, and instead set up location in South Africa, or that the film is so obviously derivative of the spaghetti westerns of Sergio Leone. Give no thought either to the historical anomaly that should have seen the 1870s town of Black Creek with at least a sprinkling of ex-Civil War veterans and other hardened men including Indian fighters who would have made the iron-fisted control over the town by the regional oil magnate and local thug Colonel Henry Delarue (Jeffrey Dean Morgan) and his puppet, the spineless Sheriff Mallick (Douglas Henshall), so very unlikely. And feel free to disregard the annoying thought as to why anyone would want to live in such a burnt-out, forbidding place as this, or why there hadn't been more (or any) opposition to the arrival in their midst some years before of two foreigners, the Dutch brothers Jon Jensen (Mads Mikkelsen) and his brother Peter (Mikael Persbrandt), soldiers who had fought against Germans in the Danish Army and had come to America to begin a new life. Sometimes it's best to leave our critical faculties at the door. How many westerns, after all, used the term 'gunslinger', which didn't appear in the lexicon until the early 1910s? So what if Levring went for style over substance. He's the director. He's entitled.

The style begins to ratchet up when Jon is reunited with his wife and son after their arrival in town at the end of a long journey from Denmark to join him. While on the stagecoach out to Jon's homestead, however, they are killed

by two drunken villains, one of whom is the brother of Henry Delarue, who is in turn killed by Jon. When Delarue learns of the death of his brother he becomes enraged, increasing the town's 'protection money' and giving Sheriff Mallick an ultimatum: unless he finds either the killer or a suitable scapegoat, he'll begin killing townspeople. A series of revenge killings by Delarue follows, the corruption of various town officials including Mayor Nathan Keane (Jonathan Pryce) is exposed, the dead brother's widow Madelaine, played by Eva Green, adds her own smouldering talents to the fire, and into it all rides Jon Jensen, fresh with revenge, seething with loss.

Levring gives the impression he'd have liked to have shown more how European immigrants furthered American expansionism (the residents of the town do seem to behave in an odd, subservient sort of way, meekly accepting the rule of the despot Delarue and his clique), but who chose instead to take the blood-splattered road full of guns that go off with bangs akin to small canons. And why not? There is a glorious sense of movement in this film, the constant passing and flapping of wagons, animals, coats, clothing, gun barrels and people. Even the immobile South African landscapes interested Levring only when infused with people in a film that lauds the movement of virtually everything except for the stillness of Mads Mikkelsen's face with all of its wonderful angular forms. The perfect face for a Man With No Name, a face made for westerns.

There are allusions to *High Noon* here, with Jensen realising it has fallen to him to rid a town of its bad guys with no help from those who live there. There might be a few clichés too many, but the film was given a gorgeous yellow ochre look in post-production that makes for some sumptuous golden/brown landscapes and interesting colour variations

(including a couple of nice post-production CGI-enhanced inclusions of actual southwestern USA backgrounds that are seamlessly interwoven) that infuse it with a look of originality that it doesn't really deserve.

Levring is unapologetic about his degree of 'borrowing' from Leone and others. 'About one hundred percent', he once told one interviewer. There are even echoes of the maestro himself, Ennio Morricone, in the score of Kasper Winding. Well, does that matter? Leone too copied others, removing the sword from Kurosawa's *Yojimbo* and replacing it with a rifle no less, and being successfully sued for doing it. And yet *The Salvation* was a big hit at the 2014 Cannes Film Festival, at least in part because as far as Europe was concerned, Levring *had* been original. Incredibly so. For a Danish film maker to create a story that was not a typically European introspective drama, with barely a nod to any kind of character psychology, using the camera rather than a screenwriter to tell a story, and in an unfamiliar genre to boot, was new not only to Levring, but to the broader Danish cinema.

Often what is original or not is merely a matter of perspective.

33. *FORTY GUNS* (1957)

Forty Guns used to be a confusing film for me; on the surface a very B-grade offering, yet full of moments that I've returned to over and over in my mind as I've tried to figure out where it should sit in the pantheon of the western. There is so much that sets it apart from the usual low-budget western

of its time: that fabulous aerial shot of Arizona's grasslands and the thundering mob of 40 riders before the opening credits have even begun, its glorious long tracking shots, the film's overt sexual references and its depiction of handguns as phallic symbols, the extreme close-ups that would only be made famous in the decade to come in the spaghetti westerns of Sergio Leone. There are moments in this movie – written, produced and directed by Samuel Fuller – that are like ingredients in a recipe that when combined produce a flavour that you haven't tasted before. So when someone asks you if you like it, you're just not sure what to say. Then you have another taste, and then another taste, and then you just keep going. Pretty soon, before you realise it, the bowl is empty. And you're wanting more.

Made during that brief window in time when movies were being seen in the widescreen of cinemascope but still were split between colour and black and white, *Forty Guns* belonged to Samuel Fuller, the American screenwriter and director who began working in journalism in New York at the tender age of twelve. If he had never come to Hollywood, Fuller's life would have been colourful enough. During the Depression he wandered the American landscape on freight trains, by the age of 30 was writing short stories and pulp novels, and he served with distinction in the Second World War. Only when his book *The Dark Place* (1944) was purchased by Howard Hawks did he come to Hollywood. Fuller directed his first film, *I Shot Jesse James*, in 1949, and in the 1950s followed that with a string of movies with controversial and violent themes – a legacy of his pulp novel days – which in turn led to *Forty Guns*, itself something of a comic book/pulp look at the west with an emphasis, in the best traditions of the pulp genre, on sex and violence.

The story is uncomplicated. Jessica Drummond (Barbara

Stanwyck) rules much of Cochise County from her sprawling ranch house (the very same Tara set from *Gone with the Wind*) with the help of her 40 gunmen. Her brother Brock (John Ericson), however, is a thug, and when the Earp-like Bonell brothers Griff (Barry Sullivan), Wes (Gene Barry) and Chico (Robert Dix) arrive in Tombstone to serve an arrest warrant on one of Drummond's men, Howard Swain (Chuck Roberson), Brock's destructive personality erupts. There follows a very 'Gunfight at the O.K. Corral-type' rivalry between the black-clad Bonells and the Drummonds, which then turns very un-O.K. Corral-like when the sexual tension between Griff and Jessica begins to develop, which leads to the town sheriff Ned Logan (Dean Jagger), who is smitten with Jessica, hanging himself. Wes also falls for the town's gunsmith Louvenia (Eve Brent), and there is that one-of-a-kind image of her face seen from inside a gun barrel, a Samuel Fuller classic moment. Wes and Louvenia marry, but tragically Wes is shot in the back by Brock, which allows Fuller to give us yet another glorious tracking shot, this time the much-touted 'gothic' scene of the widow Louvenia, dressed in black and standing alongside a black hearse, mourning her beloved husband. If only more westerns had moments like this.

Proponents of the French New Wave considered Fuller to be a major stylist, with his off-centred frames, off-screen dialogue and some wonderful low camera angles that greatly add to the dramatic impact of his movies. But for me it is those lovely long tracking shots that make me wish more directors had Fuller's eye for continuous shooting. My favourite is when Chico and Wes are talking in a first floor hotel room, then are followed as they walk out onto the balcony and then descend a flight of stairs to the street where they are joined by Griff and then Logan. The

unbroken scene continues as Logan introduces himself and they make the long walk up to the telegraph office where Griff sends his father a telegram before Jessica and her 40 men come thundering into town. Finally, Fuller says 'cut'. It is a thrilling piece of cinema.

The tornado that Griff and Jessica are caught in the midst of is ambitious for its time as well, a swirling maelstrom courtesy of several large propellers that blew so much debris about the set that the film's stuntmen refused to be a part of it, leaving Barbara Stanwyck to perform her own scene where she is dragged along behind her horse, her foot caught in its stirrup. If you believe Fuller's account of that day, she didn't complain once. The tornado allows for the development of the Griff/Jessica storyline, and if you can put to one side the fact that tornadoes occur in Kansas and Missouri but never in southeast Arizona, you should be ok with it.

Fuller, ever the maverick, also wanted to do something that studios just hate. He wanted the film to have a pessimistic ending. In the final confrontation, where Brock uses Jessica to shield himself from Griff in a gunfight, Griff shoots to wound Jessica and, when she falls, then kills Brock with a second bullet. That's not how Fuller wanted it to end. Instead, he wanted the bullet that hit Jessica to kill her and then pass through her into Brock, killing him also. I wish Fuller had got his way. The scene after the shootout, where Jessica appeared lifeless in the main street, now sees her looking resplendent in white, chasing Griff as he's leaving the town on his buggy, catching up with it and even jumping up into it – while it is still moving! If there's a scene anywhere with 'studio interference' more overtly written all over it, I haven't seen it. Still, I suppose that's Hollywood.

32. *STAGECOACH* (1939)

1939 was a great year for westerns. *The Oklahoma Kid, Union Pacific, Dodge City, Jesse James* and *Drums Along the Mohawk*, these 'A' westerns were helped into production by the public's pre-war resurgent interest in historical epics, biopics and large 'outdoor' spectacles that really began, as far as the western was concerned, in 1936 with the release of *The Texas Rangers* and *The Plainsman*. At last, the era of the almost-childlike B western with singing cowboys like Gene Autrey, Tex Ritter and Dick Foran appeared to be coming to a close. Then, in 1937, something almost inconsequential happened. John Ford's sixteen-year-old son Patrick read a short story by Ernest Haycox in *Collier's* magazine titled 'The Stage to Lordsburg', about a small group of strangers who embark on a perilous stagecoach-crossing of Indian territory. It had been eleven years since Ford's last western, *Three Bad Men*, and he wanted to return to making the genre he loved. Ford would eventually purchase the film rights for '*The Stage to Lordsburg*' for $7,500, and the wheels of *Stagecoach* began, slowly, to turn.

Stagecoach did more than any single film of its time to revitalise the moribund western genre and is a work unto itself despite its use of established conventions. Set in 1880s Arizona, its narrative is efficient and straightforward. The single word 'Geronimo', received at a cavalry camp telegraph office before the lines go dead, tells us this is a savage place where civilisation's grip is tenuous at best, heightened by the microcosm of society that is the stagecoach itself, taking its passengers across the wasteland of Monument Valley into the great unknown.

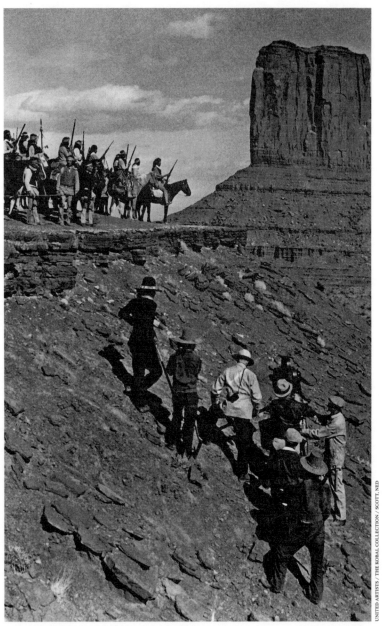

The six passengers on the stagecoach heading from Tonto east to Lordsburg were drunken prostitute Dallas (Claire Trevor), the alcoholic Doc Josiah Boone (Thomas Mitchell), whiskey salesman Samuel Peacock (Donald Meek), Confederate gambler Hatfield (John Carradine), the prim soldier's wife Lucy (Louise Platt) and the crooked banker Gatewood (Berton Churchill). Along the way coach driver Buck (Andy Devine) and his shotgun guard Marshal Curly Wilcox (George Bancroft) pick up the honour-bound outlaw the Ringo Kid (John Wayne) who is on his way to Lordsburg to kill Luke Plummer (Tom Tyler), his father and brother's killer. All begin as strangers, but what is so fascinating is seeing how the dynamics of the group begin to change, how they become ever more 'clannish', a mentality forged by their isolation, the constant threat of Indian attack, and by their own personal fears and needs.

How it all unfolds is a classic combination of action and character study, blended with a series of deep-focus, claustrophobic interior frames within the coach that prefigure the work of Orson Welles in *Citizen Kane*, who would later claim that everything he knew about directing he learned from watching *Stagecoach*. Memorable scenes include the lowering of Hatfield's gun as he prepares to kill Lucy, who is deep in prayer, convinced as he is that the Indians will capture and torture her, only to be killed himself when struck by an arrow; and of course that great chase across a vast salt flat by dozens of Indians on horseback with some great stunt work from Ringo (aka a stuntman) who leaps onto the harnessed horses, a chase with seemingly no end in sight that mirrors the endless horizon around it, an ode to the film's continual sense of movement. Although the question as to why the Apaches simply didn't shoot the horses and bring the stagecoach to a halt, rather than tiring

their horses and getting themselves killed in the process, remains a legitimate one!

Stagecoach was the only western of its era to gain a 'Best Picture' nomination at the Academy Awards – at a time when the Academy allowed ten 'Best Picture' contenders. It was an honour that was testimony to its singular narrative breadth and the fact it was, more than its contemporaries, a 'director's film', with its every aspect, angle and nuance under the personal control of its visionary creator, John Ford.

After the commercial failure of Raoul Walsh's *The Big Trail* in 1930, John Wayne had been in one forgettable feature after another. 'If you learned how to act, you'd get better parts', a frustrated Ford once told his friend. Wayne wasn't wanted for the role by the studio, but Ford insisted and got his way. Nevertheless, Wayne earned a paltry $3,000 for *Stagecoach*, a fraction of the more than $30,000 Errol Flynn was paid for starring in *Dodge City*. But it would be Wayne's breakthrough film, and its success combined with other western hits that year paved the way for a fresh resurgence in the 'A' western. This wouldn't become evident until many years later, looking back with the benefit of hindsight, when it was realised just how significant Ford's 'Grand Hotel on wheels', as *Life* magazine called it in February 1939, turned out to be.

31. *RED RIVER* (1948)

The first time I ever saw Montgomery Clift act was in the 1961 courtroom drama *Judgement at Nuremberg*, in which he had just one four-minute scene playing Rudolph Petersen, a mentally 'feeble-minded' man forced by the Nazis to

undergo sterilisation. During his cross-examination, he shows the judge a picture of his beloved mother, but fails to demonstrate he has the capacity to be a credible witness. It required only these few minutes for Clift to gain an Oscar nomination for Best Supporting Actor, and I remember wondering how many actors there are who have the talent to do that on the strength of a single scene. By 1961 everyone knew how good Clift was. And Spencer Tracy, his co-star in the film, knew better than most: 'He makes ... today's young players look like bums'.

In 1948 Clift was still to refine his acting prowess, still to find his 'voice', when he had his screen debut as John Wayne's adopted son Matt Garth in *Red River*. But the signs were there. The film also depicts a 'darker' John Wayne than audiences were accustomed to seeing, this time playing Thomas Dunson, a man who is both hero and villain, a man prepared in the film's prologue to abandon a westward wagon train that was later attacked by Indians (in which his wife was killed) in order to further his own ambitions as a Texas rancher. Dunson then meets a young Garth, who was in the wagon train but survived the attack, and takes him under his wing. When the film then fast-forwards fourteen years, Garth is being played by Clift. Dunson, having since succeeded in building his ranching empire, is preparing to embark on a complex and problematic post-Civil War cattle drive, herding his thousands of head of cattle along the Chisholm Trail through hostile territory to the cattle market in Missouri, 1,000 miles away, or else face financial ruin.

Dunson's uncompromising attitudes soon begin to alienate all those around him as the trail takes a heavy toll on his relationship with Garth. Others on the trail begin taking sides, then comes Dunson's threat to kill Garth and, of course, there is that famous fight scene between Dunson

and Garth. Too little sleep and a little too much whiskey brought Dunson undone, igniting mutinous rumblings. In some ways here was a western version of *Mutiny on the Bounty*, with the young Garth eventually wresting control of the herd away from Dunson and taking it to Missouri along a different, less arduous route. (There is also a lesser rivalry between Garth and the character of Cherry Valance, played by John Ireland, who is similar to Garth in age, temperament and in his prowess with a gun, but this relationship is never really developed, playing second-string to the main Dunson–Garth power play.)

The film brought Wayne some favourable reviews of his handling of the complex character that would become an echo of his future role as Ethan Edwards in *The Searchers*. It was also Wayne's first collaboration with director Howard Hawks, who would go on to direct him in films such as *Rio Bravo*, *El Dorado* and *Hatari!* Hawks was interested in showing how competing masculinities played out in a western setting, much like Tarantino's *The Hateful Eight*. Hawks also chose to shoot the film in black and white in an era of technicolour because he wanted the realism he felt only black and white could deliver. John Ford, the director who always felt a mentor to Wayne ever since they worked together on *Stagecoach*, would realise in years to come that while it was he who could lay claim to making Wayne a star, it was Hawks who would go on to make him a superstar. When filming on *Red River* was about to begin, Ford sent Hawks a note that read: 'Take care of my little Duke'. When it was done, when John Ford saw the picture and saw the quality of Wayne's acting, he sought out Hawks again and told him: 'I never knew the big son of a bitch could act'.

Here was an early western not afraid to take a look at the changing nature of the frontier, contrasting the

dogmatic, dictatorial and rapidly fading west of Dunson with the humane – dare we say sensitive – emerging west that belonged to Garth. Wayne was ably backed up by Walter Brennan as Dunson's wagon driver Nadine Groot and John Ireland as Cherry Valance. But there remain the film's low points, most of which revolve around the character of Tess Millay, played by Joanne Dru. There is the flow of distracting prattle that comes from her mouth while in the midst of an Indian attack that doesn't seem to be bothering her, and if that wasn't bad enough Dunson and Garth positively wither in the final scene when she gives them both a good 'talking to' that ends their fighting on the spot and has them friends again. Rather than suspending the audience's disbelief, this heart-warming moment, after two hours of testosterone-filled manliness, fuels it and is hard to fathom. The scene has bothered me for decades, and was the catalyst for me placing Hawks among those directors who had more than their fair share of shortcomings – not to mention his tendency to over-use music, in this instance the composer Dimitri Tiomkin, himself a man who always scored and orchestrated his music excessively anyway, but whose scores seemed to be accepted without compromise by Hawks, almost as though the director was aware some of his scenes needed the sort of salvaging that only music could provide.

Nonetheless, *Red River* remains a classic, thanks in no small part to Russell Harlan's classically composed cinematography. And let's not forget the many fine moods that Hawks creates, particularly the unease he generates on the night of the stampede, in the gradual deterioration of Dunson's appearance through the course of the film, and in the tense rivalry and interplay between Wayne and Clift, whose characters embodied all of the complexities of a changing frontier in two classic performances, one by a man

whose career began towards the end of the silent era, the other by the brash newcomer whose name in just a few short years would be spoken of in the same breath as Brando.

30. *RIO BRAVO* (1959)

Modern audiences aren't accustomed to the pace of 1950s westerns like *Rio Bravo*, a story with a straightforward plot that director Howard Hawks decided should take 2 hours and 21 minutes to tell. And that is a pity. Long scenes devoid of action exist only to add complexity to the film's characters, and moments when what is normally conveyed with words is achieved instead with a look. There are scenes that aren't essential to the plot but are there simply to provide enjoyment. Where are the gunfights, the mob scenes, the intimidating of people by the bad guys? Relax. What's the hurry? They're coming ...

In a tiny Texan town Sheriff John Chance (John Wayne) arrests Joe Burdette (Claude Atkins) after he kills a man in the town's saloon. The problem for Chance, however, is that the US Marshal is a week away from arriving and taking Burdette off Chance's hands. With Burdette locked up in the town jail, his brother Nathan (John Russell) begins paying hired guns to help get him out. With the town infiltrated by men either bought by or loyal to the Burdettes, Sheriff Chance has to rely on his own mettle and that of the few who stand by him to keep Burdette's would-be rescuers at bay.

There are hints of *High Noon* (again?) here, which the director Howard Hawks saw and didn't like, but with Hawks at the helm they don't go too far. In *High Noon* Marshal Will

Kane (Gary Cooper) goes about town asking one person after another for help in standing up against the men coming there to kill him, but the townsfolk are afraid and stay where they are – a none-too-subtle comment on the fear created in the early 1950s by Senator Joseph McCarthy's strident anti-communism that made ordinary Americans afraid to oppose him. Hawks instead saw *Rio Bravo* as his own 'right-wing' response to the fear-filled climate of *High Noon*. Here was a lawman intent on solving his problems by working with what he had. Chance is a pragmatist too, not the sort to try and round up ordinary people who'd be useless against ruthless gunmen, people who couldn't be counted on in a fight and would only add to his troubles by dying. 'All we'd be doing', he tells local businessman Pat Wheeler (Ward Bond) when asked why he didn't go scouring the town for help, 'is giving them more targets to shoot at'. It is Wayne's sheriff, not Cooper's marshal, who I'd rather have in my corner if trouble were coming.

Rio Bravo rolled out all of Hollywood's traditional western characters, but with a twist. There was the town alcoholic, Dude (Dean Martin), with his trembling hands and inner demons; the ageing peg-legged wise-cracking Stumpy (Walter Brennan), the guitar-toting fresh young gun Colorado (the Elvis-like Ricky Nelson) and the beautiful Feathers (Angie Dickinson), a breath of fresh air compared with the Joan Crawfords and Maureen O'Haras of the past (though the idea she should be in love with the considerably older and weather-beaten Chance is a stretch).

At the Old Tucson studios in Tucson, Arizona, where the film was made, Hawks had the buildings constructed to 7/8th scale in order to make his actors look larger than life. Larger, yes, but familial too. Chance, Dude, Stumpy, Colorado and Feathers become more like family the

further the film progresses. There is real tenderness here, emphasised by the wonderful musical sing-a-longs with Dude and Colorado that are as welcome as any shootout. Made at a time when westerns were becoming darker and moodier, *Rio Bravo* seemed at first to be superficial, a return to the 'old' ways of doing things, and was initially dismissed by critics. What they failed to see was here was a finely crafted film that told its story with a minimum of dialogue, a film that was flawlessly constructed with a likeable mix of interesting and varied characters from a film maker who was always more concerned with characters than plots.

After his epic failure, *Land of the Pharaohs*, in 1955 followed by a period of self-imposed exile in Europe, Howard Hawks had returned to Hollywood, to a country immersed in westerns both at the cinema and on television, and gave us his masterpiece of an old west populated by citizens who weren't afraid to come to the aid of those sworn to defend them, starring the one man who would never have played a Will Kane kind of character. 'What a piece of you-know-what that was', John Wayne once told critic Roger Ebert when talking about *High Noon*. 'If I'd been the marshal, I would have been so goddamned disgusted with those chicken-livered yellow sons of bitches that I would have just taken my wife and saddled up, and rode out of there'.

29. *TOMBSTONE* (1993)

Never in the history of motion pictures has a chronic illness looked so very good, and rarely has a film been made so memorable on the back of a single performance. Val Kilmer

as Doc Holliday, the sweating, feverish dentist-turned-legend, his lungs ravaged by the tuberculosis that would kill him at the age of 36, steals every scene with his mesmerising southern drawl, his elegance and elocution, his Chopin, and the fact that even when ill he's still the fastest gun there is. Holliday is an inspired amalgam of gunman and learned gentleman, played by an actor who eclipses all those around him. It is Kilmer's finest hour.

The story is familiar, mythic and timeless. Wyatt Earp (Kurt Russell) and his brothers Virgil (Sam Elliott) and Morgan (Bill Paxton) together with their wives arrive in Tombstone, Arizona, in 1879 after achieving fame as lawmen. Now they want to settle down and maybe make a fortune from the silver mines that run warren-like beneath its streets, the richest silver strike since the discovery of the Comstock Lode. Unfortunately the presence in town of the Clantons, gunman Johnny Ringo (Michael Biehn) and the gang of thugs known collectively as the Cowboys means the Earps' hopes of a quiet life will not be realised. When the town's marshal is killed by the Cowboy Curly Bill Brocius (Powers Boothe), the Earps reluctantly become the law once again.

A very square-jawed and walrus-moustached Russell is fabulous as he stares down bad guys with one-liners like: 'You gonna do somethin', or just stand there and bleed?' But it is the subtle performance of Bill Paxton as Morgan that has always been one of the film's highlights for me. A man clearly not at ease with the violence that comes with being a law enforcer, he is gentler than his brothers, a polite, decent person. 'Morgan, all quiet now', Wyatt says, as he places his hand on his shaken brother's shoulder after the last shots have been fired at the O.K. Corral. Paxton delivers an endearing performance, conveying depth and feelings with expressions what would normally require lines of dialogue.

It was something of a disjointed production, with screen-writer Kevin Jarre being replaced early on as the film's director by George Cosmatos. But it is the performances and the often sparkling dialogue that lifts *Tombstone* above the stable-full of 'O.K. Corral' homages. The script allows for the moving portrayal of Morgan, for the stoicism and dependability of Virgil, and for that scintillating scene in the Oriental Saloon when Johnny Ringo and Doc Holliday trade *un-subtitled* Latin phrases prior to Ringo's showing off with his handgun, followed by the mocking of his skills by Doc, using an empty cup to mimic Ringo's talents. If only more movies had moments like this.

Jarre also manages to create an utterly believable and flawed Wyatt Earp, a man who would have preferred to spend the rest of his life without having to fire a shot at anyone ('How'd we get into this?', he mumbles to himself as he, his brothers and Doc are about to face off against the Clantons). Wyatt's estranged wife Mattie (Dana Wheeler-Nicholson) is convincing too as his spurned, pitiful wife with an addiction to laudanum, providing the other half to a relationship that allows Wyatt to be seen as man rather than myth. Wyatt, unable to be the husband Mattie wants him to be, instead finds himself falling hopelessly in love with itinerant actress/dancer Josephine Marcus (Dana Delany), whom he would eventually marry.

Second only to Kilmer's performance is Powers Boothe's portrayal of Curly Bill, friend of Johnny Ringo and later named as one of Morgan Earp's assassins. When Wyatt leaves Tombstone after the death of his brother, he passes by Curly Bill and, looking beaten and empty, says: 'It's over'. Curly Bill replies simply 'Well, bye'. You really do want Curly Bill to get what's coming to him. But not too quick, please. He's loathsome, sure, but just too entertaining to be killed off

early. Stephen Lang as Ike Clanton is positively manic, and if you add the bravura performance of Biehn as Johnny Ringo to it all, you end up with a bounty of top-shelf bad guys, the time-honoured ingredient required of any great western.

Some critics thought the facades of this Tombstone a little too spruced up and not 'dirty' enough. I liked its Victorian elegance. And while many derided the fact it went on for almost an hour after the O.K. Corral shootout, the fact is there was an awful lot of revenge still to come. The shootout was only the beginning, and I liked that director George Cosmatos had the courage to look beyond what we all have been conditioned to think of as the finale, to show how the Earps and the posse they helped gather together eventually brought 'frontier justice' to the Cowboys and to Ike Clanton, and then to dwell on the love story between Wyatt and Josephine in what was a welcome teary closure for this sentimental old reviewer.

28. *THE SHOOTING* (1967)

Behold: the existential, dreamlike western. Just when you thought the genre was all sub-genred out, along comes a director who counts as his influences two of the world's most influential existentialists, Jean-Paul Sartre and Albert Camus. Armed with this philosophy, he then does what any self-respecting existential thinker with access to a camera, actors and a film crew would do – he abandons decades of established traditions and gives us a western quite unlike any before it, full of ambiguities and oblique motives, and with minimal dialogue. The sort of approach that says, well,

if the images on the screen of a group moving aimlessly through a barren wilderness in pursuit of something that refuses to be unveiled doesn't tell a story, then adding words will hardly help. Welcome to the stylised world of Monte Hellman, a west that isn't so much wild as desolate, with horizons so vast all they do is entrap, overwhelm and eventually destroy.

Hellman's story is, on the surface, a simple one. Willet Gashade (Warren Oates) returns to his mining camp to find his friend Coley Boyard (Will Hutchins) fearful after the killing of their former partner a few days earlier. Gashade's own brother, Coin, has fled, being suspected of a killing in town. The next day, upon hearing a gunshot beyond their camp, Gashade investigates, and finds a young woman (played by Millie Perkins) standing over her horse, which she has just shot. The woman, who is almost monosyllabic, offers Gashade a thousand dollars if he'll accompany her across the desert and help her find the town of Kingsley. Why? Well, that's not important. Gashade agrees, and Coley, who is attracted to the mysterious woman, joins them. Gashade's own compulsion to join her, though he can't say why, is what drives this film forward. Whether that compulsion was just a very 1960s kind of impulse that involves the embracing of potential oblivion rather than continuing on living the same unfulfilling, dull life or an inarticulate plot device from Hellman to strive for what existentialists call the 'superior man', well, we don't know that, either.

On their way the woman, who refuses to tell them her name or the purpose of their journey, is constantly rude and obnoxious. A man in black, Billy Spear (Jack Nicholson), is seen to be following them and eventually walks into their camp when it becomes clear he has been hired by

the woman, and tensions between the three men ramp up. After encountering a bearded man in the desert who hands the woman a letter and tells her the man she is seeking is just a day's ride away, Spear then murders Coley, whose body is buried by Gashade. After their horses perish and they run out of water, Gashade crushes Spear's gun hand with a stone, then sees the woman walking towards a man who turns out to be his brother, Coin. Coin and the woman shoot each other dead, which leaves Gashade – and us – asking plenty of questions, and an injured Spear stumbling around in the desert.

What I really enjoy about Hellman – though not everybody does – is the way he leaves mysteries unresolved. We're accustomed to having questions answered when we go to the movies, it's a part of the unwritten code that has always existed between film makers and their curious audiences. But here, as the end credits roll, there remain mysteries galore. What did the bearded man whisper to Coley? How did he break his leg? Why does he give the woman a letter, and who is she anyway? Why is it intimated she may be related to Spear just because she resembles him? If she is, it's not made plain to us. And isn't it odd that Gashade cuts a hole in the bag of flour, thus leaving a trail, when he thinks he's being followed? Or that at one point when asked where his gun is, he says he doesn't know? What is the point of all of these unresolved questions? Why isn't Gashade even able to explain why he agreed to help the woman hunt Coin? Why did she kill her horse? Hellman once provided something of a response to all this, saying the film originally had a prologue written for it which was never used, and which would have provided some clues and context. That didn't always help the poor actors. When Perkins complained to Hellman that she couldn't find the requisite motivation to

play her character because she knew so little about her, the director simply replied: 'Just do it. I don't have anything to tell you. We don't know why she's here'.

Shot in sequence over fifteen days for a paltry $75,000, *The Shooting* was filmed back to back with *Ride in the Whirlwind*, about three drifters forced to become fugitives when chased by a group of vigilantes, which began filming after a break of just a few days in the same location. If you're going to watch one you really need to see the other. ('If you're going to make one western, you might as well make two', producer Roger Corman told Hellman.) Filmed in the mountains around Kanab in southeastern Utah, the landscapes provided the imagery needed to reflect the emotional states of the characters, in much the same way that the great director Anthony Mann did in the 1950s with films such as *The Naked Spur* and *Man of the West*. Hellman's landscapes are considered – they don't do the kind of ad-hoc 'jumping about' you sometimes see in westerns, where there seems no logic to how the backgrounds unfold. Here the topography becomes progressively bleaker, rougher and threatening, reflecting the unfolding mood of the film and the internal workings of the characters.

Traditional roles count for nothing with Hellman. Rather than being focused on achieving a particular goal, the male leads in this alternate western world seem to be portrayed as characters incapable of seeing too far down the road, who spend too much time engaged in meaningless pursuits. And behind the cameras, too. The editing process altered substantially towards the film's end, becoming increasingly fragmented and eccentric.

No time frame is given for *The Shooting*, but by the look of its poorly established towns (collections of tents and shacks mostly) and the eerie lack of other people,

the 1840s or early 1850s would be a fair guess. Hellman himself often claimed that the socio-political background to *The Shooting* and its pervasive sense of imminent danger was inspired by the assassination of John F. Kennedy, a fact that might never have been obvious to anyone if the film maker hadn't said as much. The intellectual and existential angles of the film certainly made it difficult to sell, though it did make the rounds of various international film festivals, despite not being seen in America until 1971 (at drive-ins), with its theatrical premiere at the Royal Theatre in Los Angeles in January 1972 – more than four years after filming wrapped up.

What could easily have been little more than a standard B western in so many other hands instead becomes a triumph of the director's ability to take reality, twist it out of shape and in the process give it a more enigmatic feel. I thought about this picture long after I saw it. And while there are a lot of unanswered questions, mostly I think it's because Hellman simply enjoyed being mysterious. And in any case one of the movie's central themes is that there are things in life – in all of our own personal lives – that we can never know, that cannot be explained or quantified no matter how hard we look. So why should we expect it from the movies? A Hellman film is a head-on dash into a Dali-esque world by a man not interested in providing windows onto life's puzzles, but who thrives on reminding us of that most basic existential dilemma – the fact that such stuff as certainty, meaning and destiny can, when in the right directorial hands, be twisted into theatrical props for a film maker's fog-draped dreamscapes.

27. *IL GRANDE SILENZIO/THE GREAT SILENCE* (1968)

Sometimes called 'the western in the snow', this Sergio Corbucci masterpiece, set in the late 1890s in a seriously snow-bound Utah, opens with a mute gunman called Silence (Jean-Louis Trintignant) riding into an ambush by local bounty hunters, all of whom he effortlessly dispatches. More bounty hunters are about, however, all under the control of the very bad Tigrero, also called Loco (Klaus Kinski), and all eager to kill as many so-called 'outlaws' (outlaws made to be outlaws because of the high price put on their heads) as they can find, while remaining conveniently within the law. Loco is in league with the local Justice of the Peace, Henry Pollicut (Luigi Pistilli), who wants to rid the valley of what he considers undesirables. When Pauline (Vonetta McGee), a local woman whose husband was killed by Loco, offers Silence $1,000 to kill him, Silence becomes a bounty hunter hunting a bounty hunter, the very man, it turns out, who killed his parents and slashed his vocal cords.

The idea of a mute gunman was first planted in Corbucci's mind by the Italian actor Marcello Mastroianni, who once confided to the man now considered second only to Sergio Leone as an exponent of the spaghetti western that he had always wanted to act in a western, but that his total lack of English prevented him from auditioning. When the role of Gordon Junior (later Silence) was originally conceived, it was assumed he would speak, but when Corbucci learned that his eventual leading man Jean-Louis also couldn't speak English, Gordon Junior then transformed, becoming the mute named Silence. Well, who needs words anyway? This is, after all, an Italian western – the camera and the music

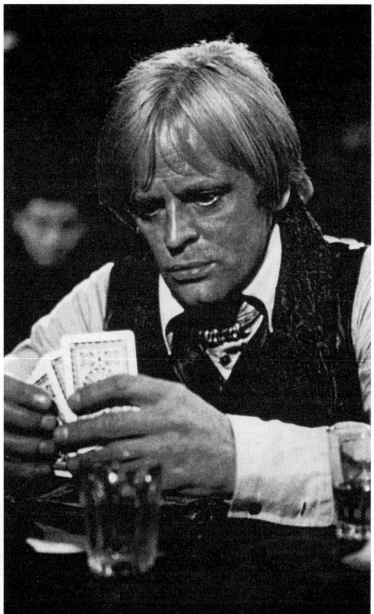

and those wonderful close-ups will provide all the story that is required, right? Anyway, when you possess the very best-looking hand-gun *any* gunfighter in *any* western has *ever* had – a silvery Mauser C96 semi-automatic pistol with its ten-round box magazine and broom handle-shaped pistol grip – you'd let it do the talking for you. Right?

Like most Corbucci films, *The Great Silence* was a thinly-veiled left-wing political statement, designed to show how greed and corruption can become embedded within unchecked authoritarianism. Pollicutt's power is misused to deny ordinary people the ability to earn a wage. The film also reflected Corbucci's own rather bleak acknowledgement that no matter how hard one tries, the individual is all but powerless to effect meaningful social and/or political change. The deaths of the Cuban revolutionary Che Guevara (9 October 1967) and Malcolm X (21 February 1965), men who died before they were able to realise the causes they were fighting for, are seen here in the eventual killing of Silence by Loco. Just as Marxists preferred to see Jesus Christ as little more than an unsuccessful revolutionary, Silence's own inability to defend the weak and the dispossessed becomes a tortured parody.

Filmed in the Dolomite mountains of northern Italy, the whiteness of the landscape is in stark contrast to the arid, barren landscapes of almost every other spaghetti western you can think of and also at odds with the film's pessimistic, sombre tones. Ennio Morricone provides one of his finest scores, and the inability of Silence to speak provides him with a refreshing vulnerability and sensitivity that few such figures of his time and genre possess. And the difficulty of moving through such deep snows provides the film with one of the essential ingredients of any western 'man-against-all-odds' storyline – detachment and isolation. There is

nowhere to run. There will be no cavalry arriving to save the day.

So if you've been exposed to a little too much Hollywood over the years and are expecting a happy ending, you'd best prepare yourself. As mentioned, Silence is gunned down in the snow by Loco, but it gets worse. When Pauline runs to his side and grabs his gun in anger, she too is gunned down by Loco, followed by a group of outlaws who are then brutally murdered by Loco's barbaric bounty hunters. There's not even a silver lining to cling to here. In fact studio executives were so disturbed by the finale that Corbucci was made to shoot an alternate ending, which is out there to be seen if you really need it. Better, though, to honour the director's original intent and remind yourself that westerns – particularly Italian westerns – and *most particularly* a Corbucci western – should never be watched if what you're hoping for is 'happily ever after'.

26. *MAN OF THE WEST* (1958)

Anthony Mann began his working life in 1923 as an actor in off-Broadway plays and later as a stage director in New York, arriving in Los Angeles in 1938 and finding work with Selznick International Pictures as an assistant director. He moved to Paramount in 1939, where he was given his first directing credit with *Dr. Broadway* (1942) before moving on to Universal, Republic and RKO, where a distinctive melodramatic style began to emerge. Then came the 1950s, and a string of now-classic westerns starring James Stewart: *Winchester '73* (1950), *Bend of the River* (1952), *The*

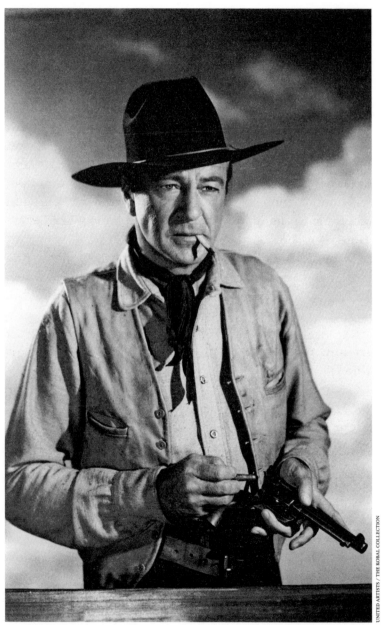

Naked Spur (1953), *The Man From Laramie* (1955) and *The Far Country* (1955). Mann was a visionary whose interest in exploring the dark recesses of the mind saw him go places other film makers of any genre rarely considered, indulging in themes that reflected the work of Freud and the German Expressionists – and the recesses of our own dark unconscious. Clearly here was someone interested in doing more than just promulgating the same old idealised west, and I can't help but think how much fun it must have been to have been a devotee of Mann's during the fifties, filled with anticipation for each new Mann release, wondering what themes, left untouched and unexplored by the rest of Hollywood, he would dissect next.

In 1958, at the height of his creativity, he made what many consider his greatest western – *Man of the West*. It begins with Link Jones (Gary Cooper) leaving his family to travel by train to Fort Worth, Texas, to hire and bring back a schoolteacher for their small town school. On the train he meets Billie Ellis (Julie London), a saloon singer who is encouraged by con-man and cardsharp Sam Beasley (Arthur O'Connell) to swindle Link out of his money. The con, however, becomes moot when the train is robbed by a gang led by Dock Tobin (Lee J. Cobb). Link, who is Tobin's nephew and a former gang member, is left behind by the train in the wake of the robbery with Billie and Sam, and together they begin to walk, eventually coming to the old farmhouse where Tobin and his gang – Ponch (Robert Wilke), the sadist Coaley (Jack Lord) and the mute Trout (Royal Dano) – are hiding out. From the moment Link opens the door to the cabin, the film's mood changes and its true intent is revealed: its descent into the madness that is the Tobin Gang, a crazed world of menacing savagery and darkness that in the history of the western up to this

point represents uncharted thematic territory for everyone – actors, directors and audience.

What starts off as a tale of redemption – of Link wanting to overcome his chequered past – has now become something much more sinister. There are disturbing undertones here, not least the question of whether the hero is even deserving of redemption. His past wrongs will be unveiled. As a former member of the Tobin Gang, he has killed innocent people. Are his sins too monstrous? Now trapped inside the dark world of the cabin, where almost a third of the film takes place, Link's past is laid bare for all to see. And he is no hero. At least, not yet.

The film's dark moments are uncomfortable to watch, not just by western genre standards but for *any* genre in *any* era, such as the scene when Link, a knife held at his throat, is forced to watch while Coaley orders Billie to take off her clothes, with the subsequent gang rape assumed. The whole look of the Tobin Gang is terrifyingly 'clannish', a savage collection of crazies and ghouls, the kind of people who can only exist beyond the fringes of polite society. The film becomes a precursor of the modern horror format, where marginalised misfits band together in America's forgotten backwaters, preying on those who stumble into their midst. The fight scene between Link and Coaley is surely one of the more brutal in the history of the western and ends with Link forcibly stripping the clothes off Coaley piece by piece, to avenge the assault on Billie. If there's a longer one-on-one fist fight in a western movie, I haven't seen it.

Dock Tobin has been planning a bank robbery in the town of Lassoo and now wants Link, whom he sees as a sort of Prodigal Son, his former right-hand man, to be a part of it. Link, however, despises his old gang members and

wants nothing to do with them. He does, however, agree to accompany them (what choice does he have?) to Lassoo the next morning, when Link's cousin Claude (John Dehner) joins them. As they leave the cabin, the music becomes overtly ominous, while the landscape, of which Mann is always so conscious, becomes increasingly barren. The group arrives in Lassoo for the robbery, which Dock is convinced will be their El Dorado, but the town turns out to be a ghost town with no bank, populated only by an impoverished Mexican couple. When Trout kills the woman, Link then shoots and kills Trout.

Link finally kills Dock ('You've outlived your time and you've outlived your kind!'), and the final scene sees Link and Billie riding a wagon out of the valley to safety. But there is more going on here. Billie, a beautiful woman who by now is clearly attracted to the man who saved her life, shares her feelings for him. Link, however, remains stoic. He is a married man, and in his unspoken rejection of Billie's advances now becomes a moral man, who has at last overcome his inner demons.

Mann's great work throughout the 1950s went largely unseen by American audiences. Just why is hard to say. Perhaps his low-budget offerings failed to attract the same notoriety as the fancier, attention-grabbing westerns of the decade, such as *Shane, High Noon* and *The Searchers*. Maybe the more thoughtful American movie-goer had been unwittingly distracted with Europe's new wave of existentialist noir typified by Fellini's *La Strada* and Bergman's *Wild Strawberries*.

Those who could see what Mann was doing, however, knew what they were looking at. Jean-Luc Godard claimed he hadn't seen anything so new since the silent days of D.W. Griffith, and wrote that what Mann was doing was nothing

less than single-handedly redefining the western. Certainly when I look back at the 1950s, as far as the western is concerned, it is to me and always has been the decade of Anthony Mann.

25. *RIDE THE HIGH COUNTRY* (1962)

Ride the High Country comes with one heck of an impressive pedigree. It stars two of the genre's most known and respected stars, together for the first time – Randolph Scott (his last movie) and Joel McCrea (his second-last movie); it is directed by a quite young (36 years of age) Sam Peckinpah who, only seven years later, would stun the movie-going world with *The Wild Bunch*; and it went on to outshine the master Federico Fellini's memorable *8½* to win the Grand Prix at the Belgium International Film Festival. Not bad going for a modest-budget western not considered good enough by a presumably jaded MGM chief executive Joseph Vogel, who fell asleep during its preview only to wake up and somehow feel informed enough to pronounce it 'the worst picture I've ever seen'. From that moment it was guaranteed a poor US distribution, but even playing at the bottom half of a double bill under the quite awful *The Tartars* couldn't hide it from the critics, who loved its vignettes of pitched emotions and the contrasting morality and pragmatism of its beloved central characters, and how those extremes brings challenges to bear on an old friendship.

The movie, set in the early 1900s, tells the story of ageing former US Marshal Steven Judd (McCrea), now too old to

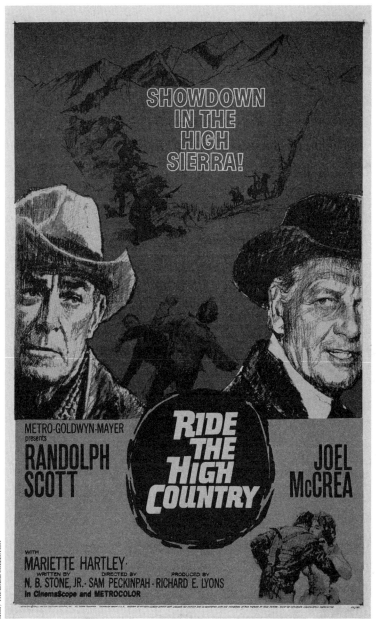

wear a badge, who takes a job as a guard escorting gold bullion from the spartan mining camp of Coarsegold in California's High Sierras down to the lowland town of Hornitos, representative of the 'new world' of automobiles and modernity. As luck would have it, Judd's old friend Gil Westrum (Scott) is in town, a similarly aged buckskin-clad relic of the old west, now past his prime and scraping by as 'The Oregon Kid' in his own lamentable carnival game, pouring buckshot into his pistols to compensate for his increasingly erratic aim. Together with his 'hustler' acquaintance Heck Longstreet (Ron Starr), Westrum approaches Judd and suggests they work together to bring the gold back, and Judd agrees, not knowing of course that Westrum and Longstreet plan to steal the gold at their first opportunity. Also in the mix is Elsa (Mariette Hartley), on her way to marry her despicable fiancé and backwoods redneck Billy Hammond (James Drury). The marriage sequence is one of Peckinpah's truly great set pieces, but the happy day is soon soured when Elsa realises that the Hammond boys see their brother's marriage as merely the opportunity to share in the delights of his new wife. Fortunately, Judd and Westrum are there to save her from an inglorious fate.

Scott and McCrea seemed to delight in their scenes together, two old pros relaxed in each other's presence and making the most of the chance to saddle up alongside each other in the twilight of their careers. But it is McCrea's portrayal of the stoic Judd that is especially touching, his values seen in the aspen groves and mountains and streams that cinematographer Lucien Ballard so beautifully captures. When it is revealed by his employers that the value of the gold shipment he'll be overseeing isn't the $250,000 he was led to believe but more like $12,000, Judd handles

the humiliation with grace, likening his role as being not dissimilar to that of the lawman he once was. Where Judd refuses to compromise, Westrum on the other hand looks to undermine him at every turn, only to have Judd counter with parable-like retorts he hopes might get through to what is left of Westrum's conscience. It is a lovely 'battle'.

Director Peckinpah manipulated the screenplay to achieve the nuances he was after, though was pretty conventional when one considers what he brought to the screen in his later years with *Straw Dogs* and *Bring Me the Head of Alfredo Garcia*. Yet watching it now, it has an air of sadness attached to it. To me it looks clearly to be a homage, a farewell to a glorious, innocent era. 1962 was a bad year for westerns, a year that saw audiences beginning to shift their attention to other, more pressing concerns. The Russians had placed ballistic missiles on Cuban soil. President Kennedy was promising to land a man on the moon by the end of the decade. There were civil rights marches, and advisors being sent to a place called Vietnam.

Ride the High Country and *The Man Who Shot Liberty Valance* were the only westerns of any real note to be made that year, which makes *Newsweek*'s claim that this was the best picture of that year in *any* genre all the more astounding. And it seemed to me, watching Scott and McCrea work, that there was an awareness of the nostalgia they were generating, a summing up of everything good that went before them, all of it ending in that wonderful, tearful final shootout ... a last hurrah to the era of the gentleman cowboy before grittier westerns out of Italy, and eventually Hollywood, replaced myth with violence, bringing a harder edge, for an edgier time.

24. *PAT GARRETT & BILLY THE KID* (1973)

Pat Garrett & Billy the Kid was meant to be another classic western from Sam Peckinpah, creator of *The Wild Bunch*, but instead it became more famous for being edited to the point of extinction and for the infighting between Peckinpah and MGM. It almost became the greatest western you never saw, with the final release a truncated, messy re-cut with over fifteen minutes of crucial footage missing thanks to the intervention of MGM president and bean counter James T. Aubrey, nicknamed 'The Smiling Cobra', who was too busy trying to steer MGM away from films and into the hotel trade to worry about delivering great movies. As a result the film failed to garner any real critical interest, and it wouldn't be until 1988 that Peckinpah's intended version was finally released on video. Only then was his story about the pursuit and eventual killing of the famous outlaw William H. Bonney (aka Billy the Kid) able to be properly evaluated. Needless to say, it was worth the wait.

Pat Garrett (James Coburn) was elected Sheriff of Lincoln County in the New Mexico Territory on 2 November 1880. Though his term wouldn't start until 1 January 1881, he was given an interim appointment as deputy sheriff and received a US Marshal's commission, which allowed him to pursue the Kid across county lines. It was one old friend chasing another, perhaps the greatest chase in the history of the west. A very 'hip' Billy the Kid (Kris Kristofferson) and his gang have echoes of Woodstock all over them in an inspired brace of 'flower power' casting including Kristofferson's wife Rita Coolidge as Maria, and sixties singing icon Bob Dylan in the small role of the frontier drifter and vagabond Alias,

a part written specially for him after he begged screenwriter Rudy Wurlitzer to include him in the production because of his life-long fascination with the myth of the 'Kid'.

The proper thing to do now would be to avoid discussing all of the behind-the-scenes mayhem that occurred on the set and concentrate on a review of the finished product. But when there's mayhem on a scale like this, well, like a horror movie, you just can't help but look. What happened is that bean counter Aubrey decided to slash the movie's budget (and therefore its shooting schedule) at the last hurdle, which led to, among other things, a Panavision technician not being employed, which resulted in the entire first week's dailies being out of focus. Peckinpah was so incensed he urinated over the screen. There was an excessive amount of drugs available on the set, excessive even for a Peckinpah film, not to mention the drinking and the occasional knife throwing and all of the usual Peckinpah dramas. Finally, at the end of it all, when the cast and crew returned to Los Angeles, Aubrey fired Peckinpah and arranged for the entire film to be re-edited – with something resembling a cleaver. James Coburn was incensed, calling the MGM version 'f**king terrible'. 'It made me sick', he would go on to say, 'after all the anguish of making the f**king thing'.

But then, just as a mound of manure is capable of growing beautiful roses, something wonderful happened. The film was left in a projection booth unattended, and two close friends of Peckinpah's, Chalo Gonzalez and Smiley Ortega, smuggled the reels out and into the basket of an MGM messenger's bicycle, and proceeded to ride off with it. They returned for the sound reels, then took it all and handed it over to the film's director. For fifteen years, Peckinpah's version would surface and resurface at various clandestine

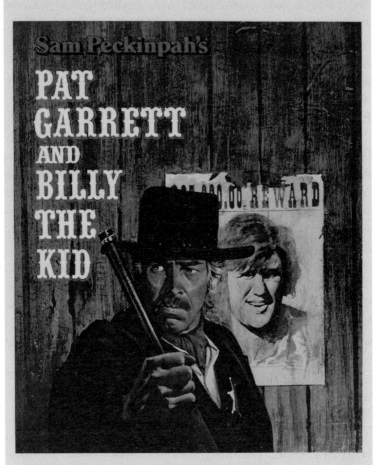

screenings. Then another slice of luck – when Ted Turner became the owner of MGM's extensive film archives in 1988, he arranged for the film to be completely restored. So, needless to say, when planning to watch what Martin Scorsese described as the only Peckinpah film to ever approach the perfection of *The Wild Bunch*, make sure you're watching what is now officially known as the '1988 Turner Preview Edition'. Okay, now to the film.

Pat Garrett & Billy the Kid is, first and foremost, exquisitely bleak. Not wanting to discount the myth of the Kid but also striving for his own typical brand of realism, Peckinpah's infusion of melancholia is perfectly reflected in Dylan's sensitive score. A reluctant Garrett spends much of it putting off the men who are paying him to kill the Kid, constantly dithering and becoming progressively drunker. The thought of having to kill the Kid brings him nothing but sadness. There is even a sense of futility to the gunfights, but it is in these moments that the film soars, such as the scene that had Billy breaking out of Garrett's jail and shooting a deputy with sixteen dimes that exit the barrel of his shotgun and hit the deputy, knocking him backwards, then following that up with one of the great lines in cinema: 'Keep the change, Bob!' Shades of Tarantino.

It's a pity that we can't generate the same enthusiasm for the supporting cast, which, though impressive (including Chill Wills as Lemuel, Jason Robards as Governor Lew Wallace and Slim Pickens as Sheriff Colin Baker) add little to the film's weight, though Katy Jurado as Baker's wife is fabulous. Kristofferson is fine, too, though a little too old to play the Kid, who was only 21 years old when he died, but Coburn's weather-beaten lines make him look quite magnificent. In fact both Kristofferson and Coburn look progressively wearier as the film progresses. Killing is perhaps weighing

them down, and Peckinpah too seems to be evolving. This is not *The Wild Bunch*. Garret wants to slow down, wants to embrace the reality that the times they are a changin'.

There are moments of sublime tragedy here, though none more heart-wrenching than Slim Pickens as Sheriff Baker, having arrived at a small homestead with Garrett and his posse hoping to find the Kid, is shot in the chest and stomach. He has just enough strength to walk over by the river where he sits down on a rock, motionless, his hand over the gaping wound in his side, bleeding out and waiting to die, as his wife watches on helplessly and Dylan's 'Knockin' on Heaven's Door' tells us he will shortly die. It is one of the most poignant moments in the western tome, a slice of directorial genius from Hollywood's visionary recalcitrant.

23. *PER UN PUGNO DI DOLLARI/A FISTFUL OF DOLLARS* (1964)

You can't talk about the films of the great Italian film director Sergio Leone without talking close-ups. The close-up is one of the film maker's standard shots, a tool, if you like, to pour more drama into an already drama-filled moment. Close-ups can show the hero looking calm when the odds are against him, or the villain's first flickerings of doubt. Bravery, fear, intent, longing – whatever the character is feeling, whatever it is they are hoping for, or hiding, the close-up allows us, sitting out there in the dark, to see it. Make-up is stripped of its ability to conceal. Who is sweating the most? Who will blink first? Long before fingers begin curling around ivory handles, it is always the face that is the first trigger ...

Close-ups have been a part of the world of film making ever since cameras first began rolling, but for me they never achieved the status, style and impact they did until Leone began to indulge his love for them in his three 'Dollar westerns' – *For a Few Dollars More* (1965), *The Good, the Bad, and the Ugly* (1966) and the first in the series, *A Fistful of Dollars* (1964). Filmed in southern Spain with a mostly Italian cast and crew, *Fistful* introduces to cinema audiences The Man With No Name (Clint Eastwood), an anonymous drifter who rides into the dusty Mexican town of San Miguel. Beset by two factions warring for its control (the Baxters and the Rojos), the town is at the crossroads of a vast smuggling region. The Man With No Name kills four of Baxter's men shortly after arriving when they refuse to apologise for shooting at his 'mule' (horse), and goes on to play one group against the other until the town's streets are littered with everyone's corpse but his own.

Leone admitted to 'borrowing' the plot for *A Fistful of Dollars* from the great Japanese director Akira Kurosawa, whose 1961 film *Yojimbo*, set in 1860s Japan, told the story of a drifter – a samurai with no name – who enters a small town controlled by two feudal crime lords fighting for supremacy, and eventually killing them all. When Kurosawa saw it, he sent Leone a letter in which he praised the Italian for making a very fine film, though adding: 'But it is my film'. A lawsuit followed, and Leone subsequently ceded the Asian rights of the film to Kurosawa, despite the widely held belief that *Yojimbo* was itself based on a 1929 novel *Red Harvest* by the American author Dashiell Hammett that had its own nameless hero. 'I was really taking the story back home again', Leone would later say.

The Man With No Name is an anti-hero – half-gangster, half-hero – a cold, dispassionate individual interested only

in how a situation can be turned to his own advantage. There is a code that he follows, to be sure, but nowhere does he feel compelled to explain himself. Everywhere he goes, he gnaws on that trademark cheroot, he is never without that Mexican poncho (which has to rank as one of the most inappropriate choices of clothing ever to be worn under a blisteringly hot western sun), always looking out from under the brim of his hat. He is also accompanied by a wonderfully eclectic assemblage of melodies, augmented by cracking whips, voices and trumpets composed by the great Ennio Morricone, the maestro whose output as a film composer now spans more than seven decades.

Morricone's music became as much a part of Leone's films as the actors themselves. It was on this film that he began his twenty-year association with his childhood friend Alessandro Alessandroni, who was himself a composer. But more than that, he was an accomplished *whistler*, and it was he who provided the whistling (and that wonderful twanging guitar) that would forever be associated with Leone's gritty masterpieces, many of the scenes of which Leone deliberately extended just so Morricone's music could be properly heard.

There is little here to be critical about, and the fact the film has been overshadowed by its successor, *For a Few Dollars More*, and in turn by the crowning glory of the trilogy, *The Good, the Bad and the Ugly*, is testimony to the well of creativity that was still to come from Leone. *A Fistful of Dollars* provided a template for the expression of an emerging genre. I can still recall suspecting, after seeing it for the first time, that here maybe was a clearer window onto the old west, a place where villains outnumbered heroes, where the towns were grubbier, the clothing more tattered, the people tired, worn out, the result of endless

toil. As a teenager seeing this unromanticised, unadorned world, I couldn't help but think perhaps this was the way the west *really* was, before Hollywood got a hold of it, and glammed it all up.

22. *SEVEN MEN FROM NOW* (1956)

In *Seven Men from Now*, the former sheriff of the town of Silver Springs, Ben Stride (Randolph Scott), sets out to find and gun down the seven men who robbed his town's Wells Fargo freight office and killed his wife, who was working there to provide income while Stride was looking for work. Tormented by the thought he had contributed to his wife's murder, Stride meets a couple travelling to California, John and Annie Greer (Walter Reed and Gail Russell), and together they make for the border town of Flora Vista. Along the way they are met by two opportunists, Bill Masters (Lee Marvin) and Clete (Don Barry), who realise Stride is after the mail office bandits and so decide to stick with Stride until he finds them, then take the $20,000 for themselves.

The film was the first in a series of collaborations between actor Randolph Scott, screenwriter Burt Kennedy and director Budd Boetticher, a former bullfighter who got his first break directing *The Bullfighter and the Lady* (1951) for actor John Wayne and Robert Fellows' Batjac Productions. When Boetticher was handed Burt Kennedy's screenplay by Wayne, who wanted to play the role of Stride himself but had already committed to *The Searchers*, he could barely put it down. 'I read 35 pages of it at lunch', Boetticher later recalled, 'and I had never read anything this good'.

Boetticher was eager to work with the unheralded Kennedy, who wrote the screenplay in pencil on a legal pad in a mere six weeks, and with Scott brought in to play the part of Stride (a lost opportunity for Wayne and one that he would openly lament), suddenly there it all was, a new era and a trio of credits that soon became familiar to western fans everywhere – Directed by Budd Boetticher; Written by Burt Kennedy; Starring Randolph Scott. One of the great and endearing partnerships in the history of the western had been born, what became known to movie-goers and critics alike as the Ranown Cycle.

The Ranown Cycle (a blending of 'Ran' from Randolph and 'own' from producer Harry Brown) began with *Seven Men from Now*, and went on to include *The Tall T* (1956), *Decision at Sundown* (1957), *Buchanan Rides Alone* (1958), *Ride Lonesome* (1959) and *Comanche Station* (1960). Everyone will have their own favourite 'Ranown' film – *Ride Lonesome* and *Comanche Station* are often cited as Boetticher's finest – but my own favourite is *Seven Men from Now*, and we are lucky to have it. A template for much of what was to come, it was thought lost for years, only to re-emerge in 2000 fully restored. Its barren landscapes mirror Stride's own sense of loneliness, and there are some nice scenes between Stride and Annie in what was Gail Russell's first film in five years, and her last. Lee Marvin as Masters, one of my very favourite bad guys and perhaps a few years later as Liberty Valance under the direction of John Ford becoming the greatest western villian of all time, is a treat in this. The scene when he and Stride, John and Annie are in the covered wagon sheltering from the rain, where he obliquely belittles Annie's husband and talks suggestively to her, is a marvellous piece of subtext in a showcase of classical acting full of skewed glances and double meanings, lit by just a single lantern, a sex scene without the sex.

Though sometimes referred to as B-movies (the 'B' was only a reference to their limited budgets – the last few were made for between $400,000 and $500,000 – a pittance), they possessed a unique quality, the result of an uncanny and almost accidental blending of three rare talents. Each movie ran between 70 and 80 minutes, was shot on a shoestring in around ten days, and always had Scott as a loner, a man of few words and matter-of-fact goodness, always on a personal mission involving an adversary who is uncomfortably close to him and that usually results in showdowns tinged with regret.

Boetticher represents an all-too-brief period in the fifties when directors such as Anthony Mann and Samuel Fuller were ingraining their personalities onto a raft of so-called B-grade westerns. His frames were formal but never showy, always stripping the narrative down to its essence and pushing it forward. There was a healthy disregard of convention, whether it be allowing the villain to have a charming, humorous side or in ambushes, normally opportunities to just shoot off more film than required, but here models of compact film making, the action always subservient to the characters at the forefront of Boetticher and Kennedy's creative, inventive, story-driven minds.

21. *JOHNNY GUITAR* (1954)

The great French-Swiss film director Jean-Luc Godard wasn't short on hyperbole when it came to describing Nicholas Ray, the director of this riddle of a movie who would go on to become the darling of the French New Wave. But when I saw *Johnny Guitar* at the sadly defunct

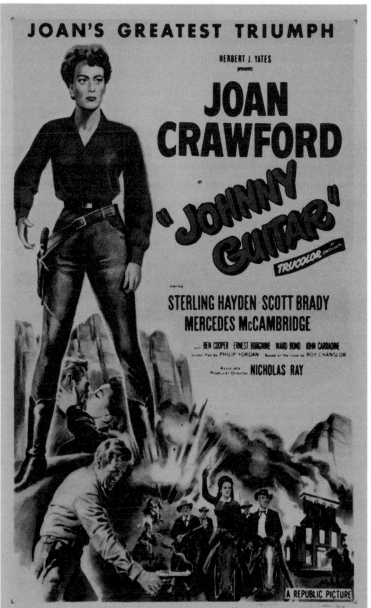

Valhalla Cinema in Melbourne's inner-city suburb of Richmond in the late 1970s, a wonderful hub for arthouse and 'audience participation' films like the *Blues Brothers*, I stumbled out onto Victoria Street afterwards dazed and confused. I thought I was going to see a western. Was that meant to be a western? It didn't *feel* like a western. The movie posters outside and in the foyer sure gave the impression it was a western. It was filmed in Sedona, Arizona, and heck, they even *talked* like it was a western! But that was the problem – the words. Or more precisely, the themes the words conveyed. They were unlike anything western audiences had ever heard before. Traditional roles and motives seemed skewed, unfamiliar, unconventional. Ambiguities were everywhere. The seeming bizarre choice of colours – the Dancin' Kid wore green, the hero looked pink, while Vienna and her nemesis Emma Small wore the familiar white and black. In westerns the men wore the dark colours, what was going on? Were the women now supposed to be the heroes and villains, and the men the sex objects, the eye candy?

It seemed to me it must have had its genesis in an off-Broadway playhouse – there was too much dialogue, and too few gunshots. 'I wonder who suggested this one', I remember thinking as I looked at the big whiteboard in the Valhalla's foyer, where patrons wrote their own suggestions for future screenings at this, the 'people's cinema'. American audiences were confused, too. According to director and film historian Martin Scorsese, some even laughed. In Europe, however, they loved it. Francois Truffaut, who adored the film's bold colours and theatricality, lauded it as a 'phony western' and referred to Ray as the 'poet of nightfall' because of his flair in setting up haunting night sequences and possessing a very European sense of 'film noir'. A pity it was all lost on

American audiences – and impressionable teenagers like me – who were raised on the westerns of John Ford and Howard Hawks. I didn't appreciate, back then, just what Ray was trying to achieve with this film. I'm a little more enlightened now.

A psycho-sexual melodrama with feminist and political overtones wrapped up as a western, *Johnny Guitar*, on the surface, tells the story of a saloon owner, Vienna (Joan Crawford), who is reunited with her ex-lover, Johnny 'Guitar' Logan after seven years spent apart. Logan walks into the saloon she now owns in a wind-swept frontier town and soon finds himself helping her in her fight with the local townspeople, led by Emma Small (Mercedes McCambridge) and the Dancin' Kid (Scott Brady), who are opposed to her plans to construct a rail station so she can profit from the coming railway. Vienna is now a self-made woman, though has clearly never fallen out of love with Johnny, nor he with her. Johnny wants to leave behind his gun-slinging days and re-invent himself as a musician, as a new man. But his efforts to change seem a little forced. Old ways die hard.

Vienna is accused of consorting with Dancin' Kid, who is the object of desire of Emma Small, whose hatred of Vienna is fuelled by jealousy. When Dancin' Kid and his gang rob the town bank, Emma convinces a posse that Vienna is behind it, and when they arrive at her saloon only to find one of the robbers, Turkey, under a table, Emma tries to have Vienna and Turkey hung. With the saloon burning down around them, Johnny saves Vienna and they flee to Dancin' Kid's hideout, with the posse on their heels. Emma demands a showdown with Vienna and then kills Dancin' Kid before Vienna kills Emma. The fighting is called off by the posse's leader, and Johnny and Vienna, safe in each other's arms once more, survive.

Ray deviates from traditional western movie conventions in the gender power plays he takes so much relish in manipulating; the persona of Emma Small, with her own bevvy of fears and maniacal contempt for what she doesn't understand, provides a perfect allegory of the anti-Communist McCarthyism of the time as she tries to appeal to the townspeople's bigotry by telling them Vienna is a 'foreigner' because she's only lived among them for five years. The film's feminist overtones are also plain to see in the dominant characterisation of Vienna, who likes to wear black, packs six-guns, takes heroic stands and is sexually strong. Add to that the tri-colour process and moody camera angles that give the film an almost hallucinatory feel and you can be sure that while you might be watching the exact same film as the person sitting next to you, chances are you're having two very different experiences.

Often overlooked these days in 'greatest director' lists, Ray was a consummate director of actors. He never told them what to do, was always prepared to deal with an interpretation that might not have been quite right rather than intervene and kill the actor's instincts. The last thing he wanted was for actors to imitate his own vision. 'No director, however talented', he once said, 'can play all the roles'.

As expected, not everyone liked *Johnny Guitar* on its release. *Variety* said Crawford should 'leave saddles and Levis to someone else', while Bosley Crowther, writing for the *New York Times*, called it a 'flat walk-through ... of western clichés'. Being filled with conventional biases certainly coloured my own initial viewing of it, but fortunately I now see it for what it is – a highly stylised and multi-layered triumph of social and political commentary.

20. *THE HATEFUL EIGHT* (2015)

Quentin Tarantino's eighth film puts to bed the idea that cowboys are men of few words. In post-Civil War Wyoming, a bounty hunter, John Ruth (Kurt Russell), is riding a stagecoach with a blizzard hard on his heels. Next to him – handcuffed to his wrist – is Daisy Domergue (Jennifer Jason Leigh), who Ruth is taking to the town of Red Rock to hang and whose fate is the catalyst for what is to come. Along the way, the stagecoach collects another bounty hunter, the former Union soldier Major Marquis Warren (Samuel L. Jackson), as well as Chris Mannix (Walton Goggins), the son of a Confederate rebel who insists he is heading to Red Rock to become its new sheriff. The blizzard, however, intervenes, forcing stagecoach driver O.B. Jackson (James Parks) to take shelter in the snowbound and appropriately isolated Minnie's Haberdashery, where ex-Confederate General Sanford Smithers (Bruce Dern), cattle-hand Joe Gage (Michael Madsen), hangman Oswaldo Mobray (Tim Roth) and the store's Mexican caretaker Bob (Demián Bichir) have been riding out the storm. The four in the stagecoach have arrived; four are already there. And that makes eight.

But there are pieces missing, specifically haberdashery owner Minnie. Warren, who has been a past customer of Minnie's, feels something isn't right. Minnie, he tells Bob, who once had a 'no dogs or Mexicans' policy only to eventually relent and allow dogs, would never have left her store in the care of a Mexican. The cowboy (Gage) has an unlikely story too, that he's heading home to visit his mother, while Mannix (Goggins) sounds awfully convincing when he insists he's heading to Red Rock to be its new sheriff. But is he? Where is Hercule Poirot when you need him? They

are supposed to be mostly strangers, yet they seem cuffed together by circumstance. Various other imponderables also emerge, as do a series of alliances and mutual suspicions. Nicely constructed conversations create and sustain several periods of great tension, and the whole thing is a testament to just what an indulgent film maker can achieve when he is given full rein to do exactly as he pleases. There would be no excuses, and no compromises either; an approach that began with a real dandy – to shoot it in Ultra Panavision 70.

When I think Ultra Panavision 70, I think of wide frontiers, mountain ranges, Second World War tank battles, empires falling and mutinies on tall ships, not the confines of a large cabin. It didn't seem to make any sense. How is the director going to achieve intimacy in such a place with such a wide format? Where will the close-ups come from? Will there even be a zoom lens capable of achieving close-ups? (No, there wasn't.) But that is the genius of the man. 'I'm an analogue guy in a digital age', Tarantino once said. He knew what 70mm was capable of. Digital film carries about 16 million colours. Film can carry billions. It would bring us so far into the cabin it wraps us up in it. So what does this mean for the audience? It means we can allow our eyes to wander, to look for clues, to study backgrounds, to choose what we see, to linger on whatever we want to linger on. We could be our own director. We'd be there.

In a film so beautifully replete with details, there was one that really annoyed me. The role of the hangman was written for Christoph Waltz, the Austrian-born actor who worked with Tarantino on *Inglourious Basterds* and *Django Unchained*, but whose character was played here by Tim Roth after Waltz turned the part down because, in his words, he doesn't play 'groupie' roles. Evidently he felt the part wasn't large enough or did not have enough to say. And

that's his right. Problem is, the dialogue – not to mention Roth's mannerisms and even his appearance – was so very obviously Waltz-ian, down to the tiniest nuance. All I did was see and hear Waltz at every turn, and wonder why he wasn't there. And wished that he were. It astonished me just how much of a distraction that was.

The camerawork is ebullient. A shot of two of the stagecoach horses, their heads heaving and thrusting forward in equine harmony, is a glory to behold and a reminder that Tarantino's capacity for tenderness and penchant for violence are within him in equal measure. Ennio Morricone's haunting opening title sequence I just can't dislodge either – from where did that gorgeous mournful double bassoon dirge come from, from what depths of imagination?

Of course, we'd have had nothing to talk about at all if not for sweet little Daisy. It is her film. Despite being mostly handcuffed, being elbowed in the face, having her teeth knocked out and having a bowl of stew thrown in her face and her brother's (Channing Tatum) brains blasted all over it, she still manages to be the scariest person in a room full of killers and miscreants. And she doesn't even kill anyone!

And lastly there is *the* prop in a room full of props – the so-called 'Lincoln letter'. My son and I debated its authenticity long after the film ended, he suggesting we should take Warren at his word that it was a fake, that he wrote it to enable a smoother path through white society, and that is the end of it. But just because a character in a movie says something doesn't make it true. So I chose to believe it was real. It was lyric and folksy, after all; it seemed to reflect the caring and compassionate Lincoln of history. In any case, what matters is we talked about aspects of the film all the way home. And on that night, that was a *long* way.

Great films make you do that.

19. *DANCES WITH WOLVES* (1990)

All movies are a collaborative effort, often the end result of years of hoping, dreaming, finding the money, overcoming near-sighted studio executives, financial and legal entanglements – and money. Always, money. And more than any other genre it is westerns – which studios perennially think cannot garner large audiences – that must not only keep within their budgets, but never go over two hours, and always, *always*, must be spoken in English. Then along came *Dances with Wolves*, and the old way of doing westerns underwent a serious revision.

It all began with the American author Michael Blake who, after becoming inspired to learn all he could about Native American buffalo culture after reading *Bury My Heart at Wounded Knee*, wrote *Dances with Wolves* at the behest of his friend, the actor Kevin Costner. When he finally was given the raw manuscript to read, Costner – who urged him to write a novel rather than a screenplay because he felt a novel had more chance of being picked up as a film – couldn't put it down. 'It was the clearest idea for a movie that I'd ever read', he said. In fact, he and the man who would go on to become the film's producer, Jim Wilson, loved the idea of a Civil War officer who chooses to live life among the Plains Indians so much they decided they had to own it, and were a driving force behind its eventual publication. Sadly, a less-than-enthusiastic publisher – Fawcett – who considered it little more than a 'romance', consigned it to 7/11 outlets and airport bookstores. But Wilson retained the film rights and together he and Costner pursued their dream, while author-now-screenwriter Blake began the arduous task of paring

down his book and turning it into a film. 'All the bones were there', Costner later told an interviewer. The first draft was promising, and Costner and Blake continued to refine it.

'What are you going to do about the language?' Blake asked Costner, realising that to be true to the book large swathes of it needed to be spoken in the original Lakota language – and by its white actors too, who would be requiring language lessons. 'Subtitles', Costner replied. And there would be no compromising. Here was a film that honoured Native Americans like few before it, a people who would be consulted at every turn, their traditions respected, their language to be heard by most filmgoers for the very first time. Blake and Costner knew that much of the film's drama would come from this use of language, from that deep well, that great divide of non-communication. Around a third of the film would eventually be spoken in the Lakota language, using subtitles – a fact that made a lot of studio executives nervous. So much so that a number of studios showed initial interest but eventually baulked, including many of Hollywood's independent studios. None would offer them the cash they needed. So they set about chasing the money themselves and eventually, with some funding from a handful of foreign investors, Orion Pictures stepped up and purchased the domestic rights and the project was given its green light. When the film went over budget by more than $3 million, Costner paid for it out of his own pocket. But it hardly mattered. The film would go on to win seven Academy Awards, including Best Picture. Isn't it odd, then, that struggling Orion put the film on its shelf for an entire year after it was completed, reluctant to release it because they thought it would bomb?

The story is set in 1863 during the Civil War, when a Union officer, Lieutenant John Dunbar (Costner), at his

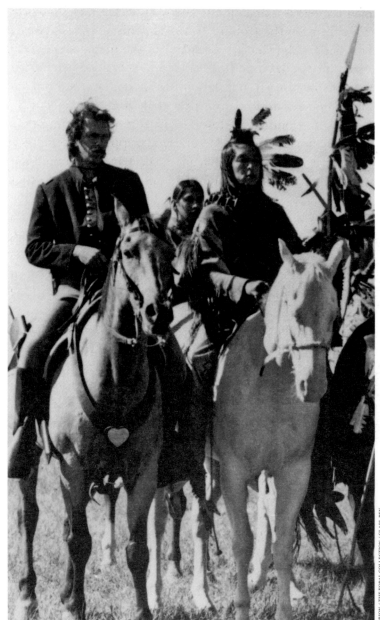

own request is reassigned to the west because, in his words, 'I want to see the frontier before it vanishes'. He arrives at Fort Sedgwick (which is deserted) in the midst of the Great Plains in the Dakota Territories and sets about creating a new life for himself in isolation. He catalogues the flora and fauna he sees around him in a daily journal, befriends a curious and oddly timid wolf, which he names Two Socks, and, when a number of Lakota Sioux appear, he embraces their arrival with a child-like glee. Dunbar is welcomed into their tribe, learns their language and loses himself in their folk tales.

Dunbar is given the name Dances With Wolves after the tribe see him chasing and being chased by Two Socks. He falls in love with a white woman – Stands With A Fist – (the fabulous stage actress Mary McDonnell) who was raised as the daughter of the tribe's medicine man Kicking Bird after her family was massacred. They marry, but the white presence in the Plains is growing and Dunbar returns to Fort Sedgwick to retrieve his diary, which he fears may lead soldiers to the tribe's village. While there he is captured by recently arrived US troops, interrogated and sent back east after refusing to act as an interpreter between the army and the Sioux. Two Socks is killed by his captors, but Dunbar is later rescued and is reunited with Stands With A Fist, only for them to leave the tribe altogether, Dunbar believing his presence with them can only bring danger.

Costner wanted the film to have as authentic a look as possible of a world no white man had seen, a sort of child's view of the west – fresh, exhilarating, a land of endless potential and horizons. The character of Dunbar had never seen a Native American, had never seen a buffalo and the audience was invited to share in this sense of wonder. No details were spared. The state of South Dakota gave the movie real road

kill. Even the costumes were all aged, all hand designed and all made with naturally tanned buffalo hide.

The film's great buffalo sequence was shot over several days, each day herding them into a genuine stampede and then the announcement: 'The buffalo are five minutes away – everybody get to your cameras!' It was movie-making at its most thrilling. Dean Semler, the great Australian cinematographer who would go on to win an Oscar for his camerawork in the movie, said: 'I think we had nine cameras on it [the stampede] – I know I was on a crane ... and there's a classic shot that's used in all the trailers ... of Kevin riding at a gallop coming up over the rise with the buffalo behind him. I was on the crane, I did that shot. We had to make sure we had several cameras on him ... to clearly show that Kevin was there amongst them. And he said he wanted to do it because it hadn't been done in 100 years, man hadn't ridden in a buffalo hunt ... and he wanted to be a part of that, he didn't want to be left out'.

The storyline is so intact and sure of itself, so confident of where it is going, and filmed with such marvellous accompanying visuals – the result of the collaboration between Costner and Semler – that one can only wonder at the fact this is Costner's directorial debut. We are seduced into entering Dunbar's new world, a world where Native Americans possess distinct and very likeable personalities. *Dances with Wolves* was more than a movie. It overcame racial divides, it took an ancient language to the world, and it showed in scenes such as when Kicking Bird pulls a toy out from under him when going to sleep that the importance of family is a thread that runs through all humanity.

18. *LOS TRES ENTIERROS DE MELQUIADES ESTRADA/ THE THREE BURIALS OF MELQUIADES ESTRADA* (2005)

Tommy Lee Jones loves being a Texan. Born in San Saba, about as dead centre in the state as you can get, he lives in a suburb of San Antonio, has a 3,000-acre cattle ranch near San Saba and another in West Texas. Passionate, too, about the issues Texas wrestles with in regards to immigration and its changing demographics (non-Hispanic whites are now in the minority). Jones, who speaks fluent Spanish, was out hunting one day with his friend the Mexican author and avid hunter Guillermo Arriaga when he suggested they should pool their considerable talents and make a movie about Texas and Mexico. After some consideration they settled on the true-life killing of Esequiel Hernandez Jr, an American High School student shot by US marines in 1997 while herding goats just a mile from the US–Mexico border. It would, he said, be a chance to explore the rugged borderlands of Texas and Mexico either side of the Rio Bravo del Norte, the Rio Grande, and to maybe examine the whole concept of 'borders', not just lines on a map but also those within the human heart, the divide between rich and poor, between desire and reality, hopes and dreams.

Melquiades Estrada (Julio Cedillo) is an illegal immigrant and close friend of rancher Pete Perkins (Tommy Lee Jones) who is shot and killed by an overzealous and incompetent Border Patrol guard, Mike Norton (Barry Pepper). Norton hurriedly buries the body, but it is later discovered and is reburied in the local town cemetery. Perkins meanwhile hears of the circumstances of his friend's death from a local waitress, and is determined to honour a promise he made

to Melquiades that, should he die in Texas, he would return his body back to his family in the Mexican town of Jiménez, which Melquiades described as a perfect, idealised place. Perkins forces Norton to exhume the body, and together they begin the journey to Jiménez on horseback. The town's lawman, Sheriff Belmont (Dwight Yoakam), who was aware of the circumstances surrounding Melquiades' death but failed to act, knows Perkins has kidnapped Norton and now begins a pursuit. Along the way Perkins and Norton have a series of strange encounters, including a poignant meeting with an old blind man (Levon Helm) who lives in an isolated cabin and gives them a meal, then as they are leaving asks if they wouldn't mind shooting him. The blind man lives alone, and his only son has cancer and hasn't visited him for six months. The blind man didn't want to shoot himself, because to do so, he said, would 'offend God'. Perkins refuses to shoot him, saying that he didn't want to offend God either.

It is not a film with a conventional narrative. Past, present and future are all intertwined with flashbacks. A labour of love for Tommy Lee Jones, who directed it, this revisionist neo-western, told very much with a 'south of the border' perspective, has many of the traditional western conventions: cowboys, isolation, cultural misunderstandings, an overtly masculine theme and a slow-moving frontier-like town. It examines the idea of 'borders' and how invisible, arbitrary lines on a map can determine people's destinies. And the border here is a particularly intriguing one, and not only because of its meandering nature. Legally it runs right down the middle of the Rio Grande, so if the river floods, the border moves. Filming occurred on the US side only, with actors on horseback shot moving away from the camera as they leave the US, then turning around halfway and returning to the US side, only filmed to look as though they had crossed

into Mexico. To save money on lighting the desert at night, the crew instead shot a series of 'night' scenes in the seven-minute window of the dusk that preceded it.

The score was written by Marco Beltrami, a composer of mostly horror films such as *Resident Evil* and a long-time friend of film maker Wes Craven. Beltrami, who had apprenticed under the great Ennio Morricone for three years, wrote a score consisting of incidental songs and tunes that were common to the border region and had an indigenous, organic feel to them. There were even a few 'Morricone-esque' pieces of inventiveness, such as flicking the needles of a cactus to create a percussion sound. Tommy Lee Jones liked what he heard. 'We have a new score', he would say. 'And I have a new friend'.

Winner of the Best Actor (Tommy Lee Jones) and Best Screenplay (Guillermo Arriaga) awards at the 2005 Cannes Film Festival, the film walks a fine line considering its geography and its demographics, and walks it with stealthy aplomb. Neither a morality tale nor a political treatise, it is just a simple story about a friendship that transcends borders and prejudice and is one of the finest directorial debuts in years from a man whose heart and soul so very obviously lies deep in the heart of Texas.

17. *THE MAGNIFICENT SEVEN* (1960)

My best guess is that I was eight or nine years old when I first watched *The Magnificent Seven*, and whether it was my impressionable age or not I don't know, but it became the film of my childhood. And then, as I grew older, of my

adulthood. I bought an early VHS recorder just so I could play it and transfer the dialogue into a script-like format that filled three of my school exercise books. It's the only movie I can quote completely, from the first word to the last. Every note of Elmer Bernstein's score is embedded in my subconscious. Filming of it began on 29 February 1960, thirteen days after I was born. Alas, sentiment on its own cannot determine the order in which these movies appear. Dropping it down the list felt like an act of betrayal. Well, I'll get over that, I suppose. Now all that remains is to try and separate fact from sentiment.

Based on Japanese director Akira Kurosawa's *Seven Samurai* (1954), the story of Japanese farmers who hire a group of *ronin* (itinerant samurai) to protect their village against bandits, *The Magnificent Seven* was filmed in Mexico and directed by John Sturges. It has the cast of a lifetime: Chris (Yul Brynner), Vin (Steve McQueen), Britt (James Coburn), Harry (Brad Dexter), Bernardo (Charles Bronson), Lee (Robert Vaughan), Chico (Horst Buchholz), and their nemesis, the bandit Calvera, played with obvious relish by Eli Wallach, who desperately wanted the role because despite having only limited scenes, many of the film's other moments either had the characters talking about Calvera or anticipating his arrival. His presence is pervasive; the whole film is about him, and what he'll do next.

On the surface it appears a typical studio project – big budget, big names, expansive landscapes, polished production values – glorying in the ethics of the gunman who only kills those deserving of being killed, of men who can defy any odds, go where they like, who step aside for no one and live by an unwritten code in a fraternity that provides a sense of brotherhood and shared values. Yet if you listen carefully to what the characters are saying here, there is a

raft of anti-hero sentiments that creep in under the radar. Vin confides that he longs to be a husband and father, that he loathes the fact he has no place to call home, that the only people whose first names he knows are bartenders and card dealers. Bernardo corrects the three children in the village who befriend him after they tell him they consider their fathers to be cowards who are afraid to fight. He tells them it takes real courage to work the soil, to be farmers, to work all day with no guarantee of what will come of it, and ends by confessing that he has '*never* had that kind of courage'.

Lee is tormented by night sweats and bad dreams because he fears the bullet in the next gun will be faster than his. He has lost his nerve and came here, ironically, to hide out 'in the middle of a battlefield'. All Harry Luck is interested in is the treasure he is convinced is in the hills and is the *real* reason his friend Chris took the job. And Britt, the fastest yet most humble? He just wanted a challenge. When Chico, who looks up to Chris, starts to talk up the life of the gunman, how it's gotten them all everything they have, Chris replies: 'It's only a matter of knowing how to shoot a gun. Nothing big about that'. In the wake of the final battle that sees Calvera and most of his men, as well as four of the seven, dead, Chico turns his back on Chris and Vin, and hangs up his guns. In a moment that echoes the last words in *Seven Samurai*, Chris says: 'Only the farmers won. We lost. We always lose'. What is *really* going on here?

The production and the cast might look polished, and the action scenes might give the impression that 'action' was back in vogue, but don't be fooled by the star-laden cast and their cinemascope surroundings. There's an awful lot of 'revisionist' western-speak going on here. The script destroys the image of the idealised gunman. The seven share the food they are given with the villagers, respect their customs, sweat

alongside them in the building of defensive walls and return to help them even after being betrayed. Farming is seen as a noble pursuit by brave men, to the point where the seven yearn for the sort of values and stability the farmers have through hard work and love of family, the sort of happiness and purposefulness the seven know they will never attain from the point of a gun. There is a very deliberate egalitarianism here, replete with the sort of statements and relationships that *Seven Samurai*, with its class-ridden hierarchy of samurai vs peasant, could never achieve.

The Magnificent Seven was a pivotal film, a turning away from the era of low-budget, psychological westerns of film makers like Anthony Mann, back to more expensive productions that had led to success at the box office in other genres with movies like *Ben Hur* and *The Ten Commandments*. Studio logic now suggested the more expensive a film was to make, the better chances it had of garnering a profit. It was an approach that helped hasten the death of the B western and, it seemed, of westerns being carried on the shoulders of a single male lead. These seven, with their mix of humility, doubt, regret, decency, fear, bravery and wit, reminded a generation – *my* generation – that what makes you cry when your heroes are shot has nothing to do with how fast they were on the draw.

16. *THE ASSASSINATION OF JESSE JAMES BY THE COWARD ROBERT FORD* (2007)

The film, *The Assassination of Jesse James by the Coward Robert Ford*, was based on the critically acclaimed 1983 book of the same name by American author Ron Hansen, whose

exhaustive research into the life of James and his gang provided fresh insights into the country's most celebrated outlaw. The film was written and directed by the New Zealand-born Australian Andrew Dominik, who was given a copy of Hansen's book by a friend who had found it in a second-hand bookstore in Melbourne, Australia. It was shot in 2005 but not released until 2007, due to an excessive (even by Hollywood standards) degree of interference in the editing process by Warner Brothers executives who baulked at the film's initial length, as well as harbouring misgivings with the contemplative character of James that Dominik had taken in his effort to remain faithful to the book. 'Less contemplation, more action!' was Warner Brothers' rather predictable rant. But Hansen's James was more than just a one-dimensional action figure. Here was a middle-aged man who believed in omens, who had an awareness of God, who had become unsure of himself, who spoke in conundrums. The arguments on how to edit the film continued. At one point, according to industry insiders, there were more than a dozen final versions of it floating about, sent all over the world by the studio for various opinions as to its length and composition.

To present new and mostly unrealised insights into the character of Jesse James, a man who had already been portrayed on the screen more than 120 times, was no mean feat. Filmed in the seemingly endless expanses of western Canada, the final theatrical version is a stunning achievement. Starring Brad Pitt as Jesse James, Sam Shepard as his older brother Frank, Sam Rockwell as Robert Ford's older brother Charley, Jeremy Renner as Jesse's cousin Wood, Paul Schneider as the outlaw Dick Liddil, and with a haunting, scene-stealing performance by Casey Affleck as the troubled Robert Ford, the film achieves a look few

westerns have ever managed to produce, with its beautifully composed Victorian interiors, autumnal colours and muted velvety landscapes.

The film is set in part in a bustling and aspirational Kansas City in the last year of James' life, a centre of sophistication brimming with homburgs and bowler hats, civility and order. Anything but the stereotypical frontier town, it is here in its midst we see an older Jesse James, now 34 years of age, himself a part of the establishment he once railed against. A self-made man of unknown origins now greeted on the street with genteel familiarity, among those who truly knew him he was a man acutely aware of his own celebrity, acting as though he felt something unseen was catching him up, and conscious of unspoken torments and regrets.

While slow to accept Ford into his confidence, the film suggests James may have singled out Ford to be groomed to eventually become his own assassin. And could that be what Ford – a misguided and callow individual at once infatuated and confused by his hero worship of James – really wanted all along? (Though it's equally plausible that Ford chose to kill him simply for the reward.) What cannot be denied is Affleck's performance – diffident and looking at times gaunt, he possesses more unnerving mannerisms in his twisted innocence than the rest of James' gang put together. And James seems ripe for the taking, all-too-aware of his own vulnerabilities, struggling with melancholia.

The film doesn't end with James' demise, but continues its focus on Ford and the sad life he continued to lead. The bitter irony of his actions is that Ford missed the presence in his life of Jesse James, and as the final narration in the film tells us, regretted killing him. But no tears were shed for Robert Ford. The man who in turn shot and killed Ford, Edward O'Kelley, was released from prison after serving

only eight years, when a petition containing more than 7,000 names of people clearly more enamoured with James than with his assassin was presented to the Governor requesting his release.

Jesse James never stole from the rich and gave to the poor; he and his gang kept virtually all of the money they stole. The romanticised outlaw of newspaper stories and children's books never existed, and was largely the creation of John Edwards, the writer and founder of the *Kansas City Times*, with whom James occasionally collaborated in the wake of his robberies. Edwards wrote up his gang as ex-Confederates who were simply striking back at the corruption of entrenched Missouri Republicans. That was fiction. Jesse James admitted to committing seventeen murders over twelve years, and probably more, and the fact he was shot in the back of the head would surely have been welcomed by the relatives of the victims he left behind.

15. *THE MAN WHO SHOT LIBERTY VALANCE* (1962)

The Man Who Shot Liberty Valance was one of the very first westerns I ever saw, perhaps *the* first western, though it wouldn't have premiered on Australian televisions until the late 1960s at the earliest. By that time I'd already been smuggled under a blanket into drive-ins to see movies, some of which would certainly have been westerns I was considered by the censors to be too young to see, aided and abetted by mum and dad, whose desire to be responsible parents was exceeded only slightly by their love of drive-in movies. I do remember sitting on the lounge room floor at home

watching it with dad on our Stromberg Carlson television, and thinking Lee Marvin was the toughest-looking bad guy the movies ever had. Boy, was *that* right. A marine in the Second World War, he made over twenty beach landings against the Japanese in the Pacific, including the Battle of Saipan where most of his company were either killed or wounded. When his sciatic nerve was severed by a machine gun's bullet, he was discharged, became a plumber's assistant at an amateur theatre in Woodstock, New York, and was offered an acting role when a part came up that required someone who was tall, lean and sort of boozy looking. If he hadn't got that break, well, I'd have grown up with a different favourite tough guy, perhaps the sort who only 'acted' like the 'toughest man south of the Picket Wire'.

The Man Who Shot Liberty Valance didn't *look* like a John Ford film. It wasn't shot in Utah's Monument Valley, or any other outdoor location for that matter, consigned instead to the familiar sets of the Paramount backlot. And where was the colour? What's with shooting in black and white in 1962? Weren't studio executives already pulling their hair about how best to successfully market the waning western genre? Ford would always say he chose black and white because he felt the shadows could be accentuated and played with, moods one could create. Think of the noir! Black and white provides purity, and besides if you're filming night scenes in dark alleyways what do you need colour for anyway? All good reasons to be sure, but the fact was the studio was looking for ways to cut costs, and filming in black and white on a backlot is a whole lot cheaper than being on location and filming in colour. John Ford, coming to the end of his career and making what would be his final western, was given no choice in the matter. And it's just as well he wasn't. With its dark, un-Ford-like themes, its stage-like appearance

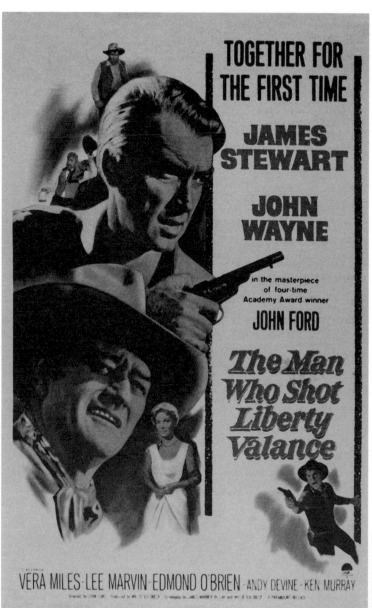

and almost claustrophobic interiors it *begged* for black and white. Paramount, with its penny-pinching mind-set, had inadvertently got it right.

The movie tells the story of Senator Ransom Stoddard (James Stewart), a former lawyer now a successful and respected politician, who travels from Washington to Shinbone (likely in New Mexico but also could be Arizona, the film never bothered to say), the town of his youth, with his wife Hallie (Vera Miles) to bury his old friend Tom Doniphon (John Wayne). While in town some reporters from the local *Shinbone Star* newspaper corner the man everyone always believed, because they thought they'd seen it, had shot and killed the outlaw Liberty Valance. But it is years later now, and Stoddard's conscience could bear it no longer. He'd always known he wasn't the man who shot and killed Liberty Valance that night. His shot missed its target. But the west needed its heroes, and when Doniphon told Stoddard it was in fact *his* bullet that killed him, fired from a shadowy side alley, he convinced Stoddard to keep it a secret so as not to interrupt Stoddard's run for public office. Now, 25 years later, Stoddard begins to tell the reporters what *really* happened. The film then unfolds in flashback, becoming a fable about our need for mythology, about how the west transitioned from a lawless wilderness to being a place of civility and order using the killing of Valance as a convenient turning point, and in the process becomes a film that provides a turning point all of its own in the evolution of the genre.

It may have been Ford's last western, but the man had lost none of his spark. Lee Marvin later reminisced that if Ford had a particularly difficult scene to shoot, he'd leave it till late in an afternoon and would get the actors on their marks, the crew in their places and then, when

everything was ready, would say: 'Okay, let's come back in the morning and shoot it'. The actors, the crew, all go: 'Huh? What?' That's how Ford got what he wanted. He'd let everyone sweat the scene out ... all night long. Come the next morning, and the actor's marks and the cameras and the equipment have all been put away, and everyone begins from scratch. Only it was not *really* from scratch. Why? Well, because 'you've been up all night thinking about how you're gonna do it'.

In the end, the killing of Liberty Valance was murder, not self-defence. And here lies the irony, that we live in a society founded on the rule of law but that remains stubbornly tied to violence, that even as individuals we keep ourselves in our own personal, hidden states of denial, preferring myths or what we prefer to *think* is real, to what *is* real. We all have our means of coping. Stoddard thought the answer to the problem of Liberty Valance could be found in the law. Doniphon's solution was more 'pragmatic'. The more 'visceral' approach prevailed. I think it has 'revisionist' written all over it, and is considered by many to be the tentative beginning of the western's revisionist era. John Wayne's Doniphon is no *Stagecoach*-like hero. He seems to shoot Valance not because Valance is terrorising the community of which Doniphon is a part, but over a steak dinner. It is a stunning change of perspective from Ford, and how clever did he prove to be, to make a film that was a reaffirmation of the need for myth, while simultaneously tearing those old myths apart?

When Ransom Stoddard comes to the end of his story, having revealed the truth about who really shot Liberty Valance, the reporter Maxwell Scott (Carleton Young) tears up the notes he'd been making and throws them in a fire.

'This is the west, sir', he says. 'When the legend becomes fact, print the legend'.

14. *PER QUALCHE DOLLARO IN PIU/FOR A FEW DOLLARS MORE* (1965)

A total of nineteen westerns made the Top 100 in terms of box office takings in 1956, the best year in the genre's history, but by 1958 the number had plummeted to just five. Its coming demise was predicted by critics and seemingly signed off on by cinema-going audiences as well. People were wanting something new on a Saturday night – new locations, new themes; they were tiring of the same old landscapes. Increasingly, its big, bankable stars (and directors like Ford and Hawks) were spending years away from the genre, working in other areas. The 1960s seemed to have problems too big for one man, no matter how big his boots, to fix: the Cold War, Civil Rights, Vietnam. And anyway, every genre had its cycles, whether epics, noir or musicals. Why should the western be any different?

Then in 1965 came Sergio Leone's *A Fistful of Dollars*, and the genre was thrown a lifeline that lifted the production of westerns that year to a more respectable 22. Who'd have ever thought the pedigreed, once invincible American western would one day become so seemingly stale that it would be regenerated by Italian and Spanish casts and crews working in Italy and Spain, or that *A Fistful of Dollars*' heir, *For a Few Dollars More*, would be that rarest of movie commodities – a sequel that took the best elements of its predecessor, and added to them in such a way that no one was left under any

illusions: the spaghetti western was the tonic the western had been looking for. The way was now paved for a new vanguard of ultra-realism that culminated in 1969 in something not even the Europeans saw coming: Sam Peckinpah's seminal *The Wild Bunch*.

Sergio Leone's follow-up to *A Fistful of Dollars* saw the return of Clint Eastwood as the serape-wearing drifter – but only just. Eastwood hadn't even seen the *first* film when Leone asked him to do the second. A print was rushed to Hollywood. Eastwood, despite the print being in Italian, loved the visuals he saw, and agreed to revisit the role. Leone was predictably thrilled to have him back because this time, instead of casting a man whose ability to be an international star was untested, he now had the Eastwood he wanted, the character he himself had shaped and crafted.

Filmed in Almeria in southern Spain, Leone again turned to his old friend Ennio Morricone to write the score, which he wanted composed before the film was shot so he could do what few directors do and let the music determine the length of the scenes. It begins with a lone rider, a speck in a vast, empty Andalusian desert. He is whistling to himself – and is then shot off his horse by an unseen assassin. Morricone's music hops in, and the music triggers something deep inside of you, something ineffable, like a shot of adrenalin. Then there's the exhilaration that comes when title designer Iginio Lardani's credits splash across the screen. Lardani was the third point in the spaghetti western's bright, shining star of inventiveness, the man who redefined what opening title credits could say. And unlike Leone and even Morricone, whose work at least had some vague precedents to draw on, Lardani's credits had no previous reference in the genre. Created by a man who began his life in film by designing posters, his kinetic

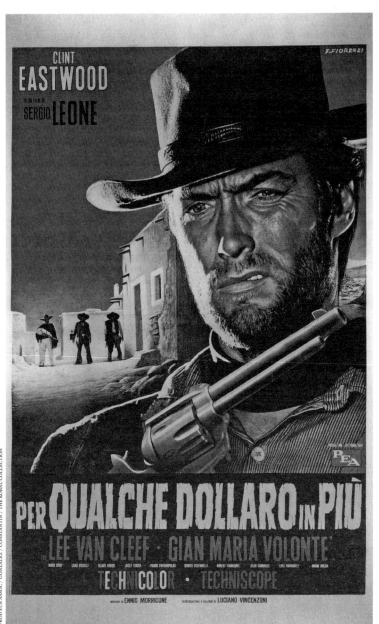

typography is punctuated by gunshots, accompanied by Morricone's twanging electric guitar and choir and strings. The combination of titles, music and Leone's stationary extreme wide shot helped establish the first few minutes of each of the Dollars Trilogy as one of the most iconic series of openings in movie history.

Eastwood's Monco (*manco* in Italian, meaning maimed person – he does everything with his left hand except shoot) is a bounty hunter who teams up with Colonel Douglas Mortimer (Lee Van Cleef) to chase down El Indio (Gian Maria Volonte), a bank robber and murderer freed from prison by his gang and now planning to do the unthinkable – rob the impregnable Bank of El Paso. El Indio is a psychopath, who has a musical pocketwatch that he plays before every duel. Unknown to Monco, Mortimer has his own reasons for wanting El Indio dead – he holds him responsible for the suicide of his sister. The film has some of the finest 'Spaghetti' moments you'll ever see – the unfurling of Mortimer's impressive gun cache, the 'hat duel' in the street between Monco and Mortimer, Mortimer and Monco's shooting of apples on a tree …

You feel with this movie a sense that something truly new in cinema had arrived, that *A Fistful of Dollars* wasn't just an aberration. Subtle progressions from *Fistful* are everywhere. Humorous asides are now more embedded within established lines of dialogue instead of being distractions that take the audience away from the story. The editing here is more sophisticated, there is the use of flashbacks, the characters are given proper motivation for their blood-letting and the movie is longer because Leone is learning to take his time, a state of mind that will reach its zenith in his operatic *Once upon a Time in the West.*

13. *THE REVENANT* (2015)

It's always made me squirm to see an actor pierced with an arrow rather than being shot with a bullet. With a bullet you can at least hear it being fired, and so this gives you a brief moment to adjust. You know it's coming. Then, when it *does* hit, it either passes through the body or stays in it, so mostly there's nothing to see except the unfortunate target falling to the ground or being propelled backwards or sideways by the impact. Pretty standard stuff, body parts flying off and Quentin Tarantino notwithstanding. It's gruesome, but at least it's mostly clinical. An entirely different dynamic, however, surrounds the arrow. Arrows are stealthy, silent. You don't know they're coming. And you're not prepared for when they do. Worse than that, when they hit, they lie half-embedded in their prey, so you can see precisely *where* they strike and precisely why the person, if not already dead, isn't happy. If someone's alongside them when they're hit, they'll invariably try to alleviate the victim's suffering by grabbing the shaft of the arrow and proceeding to yank the thing out. Give me a bullet any day. Arrows are a nasty business.

A few minutes into *The Revenant* there's an ambush by Arikara Indians on a fur expedition deep in the wilderness of South Dakota on the banks of the Missouri River. Arrows come from nowhere, and everywhere, and one after another the men are cut down. The audience is immersed in the scene, which was shot with extra-wide-angle lenses mounted on small, lightweight mobile cameras – a technique the industry calls an 'elastic shot'. The result is a gruesome, highly charged and visceral assault in which there are barely

any editorial cuts and it is plain that the film's director, Alejandro Inarritu, will be holding nothing back in his relentless pursuit of realism.

The survivors escape the assault by taking to the river in their boat, which they soon decide to abandon because remaining on the river makes them too easy to track. At the suggestion of the expedition's guide, Hugh Glass (Leonardo DiCaprio), they seek an overland route back to the safety of Fort Kiowa, during which Glass is attacked by a grizzly bear – an attack that has some basis in the historical record and became a frontier legend after an account of it was published in a Philadelphia literary journal in 1825. Whether history or not, the bear attack (filmed in a small glade in Squamish, British Columbia) remains a scene of singular magnificence, with trees made of rubber so that DiCaprio wouldn't break any bones when the pulley system he was attached to thrashed him about. A CGI-bear was added later in post-production, and the effect is cumulative, coming as it does on the back of every scene that precedes it, scenes of stark beauty made all the more remarkable given the brief amount of daylight they had to work with at the latitudes they were filming – sometimes as little as four or five hours a day.

The film is loosely based around the exploits of Hugh Glass and is set in the 1820s, decades before the era of westward expansion that defined the old west of popular imagination, a time when the west was truly unknown and untamed. Glass and a large party of trappers were scouting for beaver pelts for their employer, the Rocky Mountain Fur Company. Glass's Pawnee wife (Gracey Dove) had been killed years earlier by French soldiers, leaving just Glass and his son Hawk (Forrest Goodluck), though no historical evidence has been found to suggest Glass ever had a son.

After the bear attack Glass was so near to death he could hardly speak, and was carried on a stretcher through the wilderness much to the ire of fellow expeditioner, the brutal, racist and uneducated symbol of true frontier savagery, John Fitzgerald (Tom Hardy). Fitzgerald and the young Jim Bridger (Will Poulter) agree to stay with the injured Glass until he died of natural causes, while the others pushed on. However time passes and a determined Glass refuses to die. With Glass too weak to intervene, Fitzgerald gets into an argument with Glass's son and kills him, and later places Glass in a shallow grave and, along with a reluctant Bridger, leaves him for dead. Now alone in the wilderness, Glass claws his way out and crawls to the body, places a small piece of moss between his lips, then embarks on an epic 200-mile journey back to Fort Kiowa and, it is assumed, to a vengeful finale.

Cinematographer Emmanuel Lubezki and production designer Jack Fisk must be given plaudits for the stunning visuals they created in a movie that has a number of lengthy moments of dialogue-free drama, where images are all that are needed to drive the story relentlessly forward. There are close-ups aplenty here, too – close-ups that Leone himself would have envied, including when Glass's face is so close to the camera his breath fogs up the lens; one of many moments that draws the audience deep into the character's psyche.

In real life, Glass did manage to return to Fort Kiowa and did eventually catch up with Fitzgerald (who had fled the fort), but chose not to kill him (or Bridger). More than just a 'revenge flick', the film examines man's relationship with his environment, highlights the gulf of ignorance that separated frontiersman from Native American and gives some interesting insights into class structures and the

hierarchy that existed between employer and employee. The 'revenant' – that dead spirit that returns to exact vengeance and to terrify the living – becomes instead a tale of survival and, ultimately, of honour.

Inarritu refused to employ any CGI to enhance the film's landscapes and insisted on shooting in natural light, decisions that infuse the film with a rare degree of realism, harshness and an extraordinary beauty that sees it stand on its own in the cinema of *any* genre as a singular achievement. The sense of extreme isolation, of man against nature, is palpable, and an encouraging reminder to any of us tempted to think there are no wild places left. There are. Some crew members either quit or were fired because they refused to work in the –25°C temperatures, and DiCaprio himself had to endure his own tribulations, which included swimming through and climbing out of icy rivers, even eating raw bison liver.

The west was never so wild.

12. *BUTCH CASSIDY AND THE SUNDANCE KID* (1969)

In a genre that idealises an era, it is its most idealised scene. A man and a woman are on a bicycle; she's on the handlebars, he's doing the pedalling. They are laughing and affectionate, but they are not lovers. Or are they? It's a perfect moment; you can see it in their faces. And the actors just can't wipe the smiles off them. To watch this moment of utter contentment is to ache. 'Nothin's worrying me …', says the song. It's so idyllic, it's disarming. Why, you might even find yourself wondering about the various paths your

own life could have taken at one of the many junctures we've all come to. 'Butch, do you ever wonder if I'd met you first, we'd have been the ones to get involved?' Just another of those 'what ifs'. The world's full of 'em, isn't it? Butch replies that indeed they *are* involved, because of the shared experience they just had. And so they walk together, living in the moment. What do you do in response to this? Do you weep, descend into melancholia? But isn't this supposed to be a western? Why are we even contemplating weeping? And come to think of it, why hasn't Butch actually killed anyone yet? He's an outlaw, isn't he? Why is he so likeable? No wonder the poor critics were so confounded. *TIME* magazine, Roger Ebert for the *Chicago Sun-Times* and all those who were supposedly 'in the know' said it was a poor film. Wow. Mental note: never enter a cinema with too many preconceived ideas.

At the time, Robert Redford, the co-star alongside Paul Newman and Katharine Ross, the two on the bicycle, thought the whole scene and the music that accompanied it were 'stupid'. Like the critics in the wake of the release of *Butch Cassidy and the Sundance Kid*, even he'd been fooled by what he saw. And he was in it! Obviously this was not a typical western. In fact, at times it seemed as though it was doing all it could to deny it even *was* a western. It contains three musical montages, after all, and had two outlaws who not only refused to actually shoot anyone (until the final scene), they went and did what no other outlaws have ever done in the history of the genre – they ran away from their pursuers, and all the way to Bolivia, no less! One can easily be caught off guard by all this unfamiliarity. Redford later admitted his error in relation to the bicycle scene and its iconic song, 'Raindrops Keep Falling on My Head'. 'Boy', Redford happily confessed afterwards, 'was I wrong about that'.

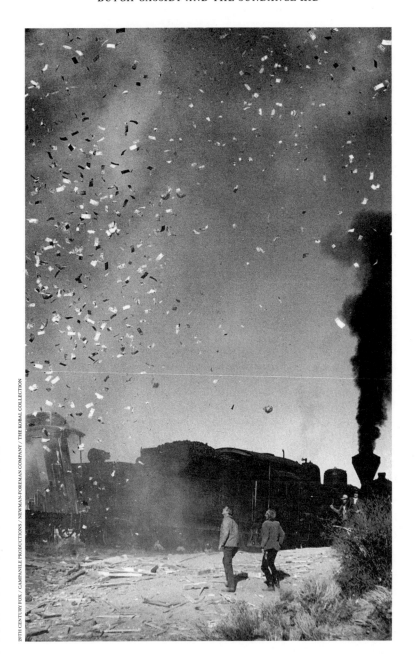

The movie has as its inspiration the real-life Butch Cassidy (Robert LeRoy Parker), his turn of the century 'Hole-in-the-Wall' gang and Parker's friend, the fastest gun in the west at that time, Harry Longabaugh, aka the Sundance Kid (Robert Redford). Screenwriter William Goldman had begun researching the career of Butch Cassidy in the late 1950s, many years before his first attempts at a screenplay. And when he'd written it, no one wanted it. 'John Wayne don't run away', one studio executive told him before 20th Century Fox purchased it for $400,000.

Goldman's original story was good, but it didn't have the depth and dimension that the film's director, George Roy Hill, would eventually give it. Hill knew what he wanted, understood the importance of narrative and had an eye for detail. More importantly, for the sake of entertainment, he knew the potential detail and historical accuracy had for getting in the way of a good story. Though the movie opens with the line 'Most of what follows is true', what follows is, of course, almost entirely fictional. In reality Butch and Sundance could never have had the sort of relationship we see here, a glorious set of opposites with Butch the joker, the dreamer, the thinker and the straight man Sundance, always trusting in Butch's ability to find an answer to every challenge.

TELEGRAM, dawn, June 2, 1899, Union Pacific Railroad Office, Omaha, Nebraska: *'No. 1 held up a mile west of Wilcox. Express car blown open. Mail car damaged. Safe blown. Contents gone'*.

The above telegram was one of those incidental moments in the history of the west that signalled the demise of the frontier, of the opportunistic way of life lived by the outlaws and renegades of the west that thrived on the lawless prairies of the open range. The telegram alerted railroads magnate Edward Henry (E.H.) Harriman that Butch Cassidy's Hole-

in-the-Wall gang had just committed what would become the most audacious robbery in the history of westward expansion. Made to stop by Cassidy and his gang, the train and the passenger cars were pulled apart, separating them from the carriage carrying the safe. They then packed the door with explosives and blew the car sky high, reducing it to twisted metal, with money floating above the plains, picked up by the wind – more than $1 million in today's money in a single heist. In the film, the train was followed by another train, the train carrying the 'super-posse', men hired by Harrigan to stop at nothing to apprehend Cassidy and his gang. The relentless chase that follows forces Butch, Sundance and Etta to flee to Bolivia, where they engage in a series of bank robberies before being hunted down by the Bolivian *rurales* and finally killed in one of the genre's most famous shootouts.

The historical record says that never once, during his nineteen-year period of robberies from 1889 to 1908, did Butch Cassidy shoot so much as a single person, with the exception of that final shootout in the small Bolivian town of San Vicente. Friolan Rizo, an inhabitant of the town, says his father, who was in town the day Butch and Sundance were killed, told him they were carried dead out of their hiding place, and did not die in anything like the final charge Newman and Redford made into that hail of *rurales* bullets. Others who were there say they both survived. Whatever the truth might be, George Roy Hill knew enough to stay as far away from it as he did, and in the process bequeathed us a glorious alternative.

11. *HIGH NOON* (1952)

The list of Hollywood's leading men who were offered and then rejected the role of the besieged Marshal Will Kane in Fred Zinnemann's *High Noon* reads like a who's-who of the Screen Actors Guild: Montgomery Clift, Marlon Brando, Charlton Heston, Kirk Douglas, John Wayne (who hated the idea of a marshal who stays to defend a town where no one will lift a finger to help him) and producer Stanley Kramer's first choice for the role, Gregory Peck. Peck, an ardent Democrat and fierce critic of the McCarthyist hysteria that resulted in ordinary people being made to cower before an approaching menace and failing to stand up for their beliefs, spent years regretting his decision, though he was always happy to admit it was unlikely he'd have been able to deliver the same bravura performance given by Gary Cooper.

If all you ever saw of *High Noon* was the few minutes of footage just before midday when Marshal Will Kane of Hadleyville, abandoned by the people he had vowed to protect, sat alone writing out his Last Will and Testament before walking out to face his would-be assassins, you'd quickly become convinced of two things. The first: that no matter what anyone had ever said before or would say again, Gary Cooper *could* act (and in this scene without even opening his mouth), and the second, that the director Fred Zinnemann was a man of singular vision and exquisite insight. The image of that clock ticking down the minutes to the final shootout is positively hypnotic. Ticking never sounded so loud.

Shot in black and white and in high contrast imagery over just 31 days, the film begins with a wedding. Will Kane and Amy Fowler (Grace Kelly), a pacifist Quaker girl, have just

been married. When the ceremony is over, Kane takes off his marshal's star and pins it to his holster. His law-enforcing days are over, his replacement arriving on the next day's train. 'This town will be safe 'til tomorrow'. But if only that were so. Just then the station master bursts in with some terrifying news. Frank Miller, an outlaw Kane had sent up for murder several years earlier but who had managed to avoid the hangman's noose, would be returning to Hadleyville in a little over an hour on the noon train, to confront Kane in a final shootout. 'Get out of this town this very minute ...' the station master pleads. And indeed Kane's first instinct is to do just that. But avoiding a fight isn't in his make-up. 'They're making me run', he tells Amy as they're leaving Hadleyville over open country on their buggy. 'I've never run from anybody before', Kane says, and with that, despite no longer being its marshal, he turns the buggy around and heads back to town. Amy, however, refuses to stay there to watch him die and vows to leave on the same train that's bringing Miller. 'I won't be here when it's over', she tells him.

Arriving back in town, Kane has about an hour to raise a posse of deputies, and it is here that the real tension begins. Townsfolk with no backbone for a fight begin to leave. Even Judge Percy Mettrick (Otto Kruger) is seen fleeing. Kane goes to the town's former sheriff, Martin Howe (Lon Chaney Jr), for help, but Howe tells him he'd be more of a burden to him than a help. 'It's all for nothin' Will', Howe says to himself after Kane leaves. The figure of Helen Ramirez (Katy Jurado) too is interesting. Once the lover of Frank Miller, and then of Kane, her presence as the town's saloon owner adds complexities to relationships and layers of possible motives. Even the unwillingness of Deputy Marshal Harvey Pell (Lloyd Bridges) to side with Kane can be linked to his own attraction to Helen, and a possible rivalry.

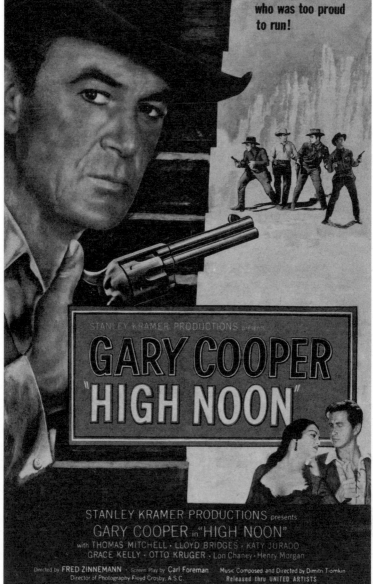

All those who decide to stay in town refuse to help. Multiple close-ups of clocks relentlessly ticking down the seconds draw the audience into the mind of Kane, a man unsure of his ability as a gunman, unable to control his wife, hoping that prison has made Miller a better man. You feel that here is a man who is not as sure as he needs to be, who wants to flee, but knows he'd be unable to live with its consequences. We sense what he is feeling, we sympathise with his failings, grapple with his loneliness. And as those around him abandon him, we partake in his despair.

The perspectives in this film are simply gorgeous: the abandoned streets, the angled camera lens giving scenes a heightened sense of drama, as if they weren't already dramatic enough, the empty railway tracks disappearing into the background, the sound of the whistle and puff of smoke that signals the arrival of Will Kane's moment of truth, the camera panning up to reveal Kane alone in the main street of what looks like a ghost town. A reckoning is coming, and not just his own, but that of the silent men and women of Hadleyville, immersed in their own shame and guilt, mutely awaiting the arrival of Miller and knowing it signals their own demise as moral creatures. There's action aplenty in *High Noon*, but not the sort of action early 1950s audiences were accustomed to seeing. Here the drama is wrapped in an unsettling foreboding of what is to come, in an increasing sense of dread and abandonment – themes more dramatic than any Main Street shootout, which, when it does come, as it inevitably must, seems positively anti-climactic by comparison.

Cooper brought more than just his acting prowess to the role of Kane. Suffering from stomach ulcers and a persistently sore lower back, his anguished demeanour seemed so authentic it was hard to know where the acting

ended and real life began. The score by composer Dimitri Tiomkin is often hailed as a classic, and there are moments when it positively soars, like in 'Two Minutes to Twelve' (sometimes called his 'Clock Montage'), when all the clocks in Hadleyville seem to combine into a percussive wrecking ball that threatens to engulf Kane before a gunshot's even fired. But it is also annoyingly repetitive, with the film's ballad 'Do Not Forsake Me, Oh My Darling', sung by Tex Ritter, repeated no less than 25 times! While the song's lyrics undoubtedly capture Kane's fear of losing Amy, who has already made it plain she won't be waiting around to see if he survives the coming fight, the movie remains horribly over-scored, not an uncommon complaint in 1950s Hollywood.

Is Zinnemann's masterpiece what many liberals said it was on its release, a timely left-leaning indictment of McCarthyist excess, or ironically is it what opposing right-wing ideologues eventually came to view as an example of the lone patriot upholding the right to self-defence? Or maybe it is its ability to be all things to all people that is the ultimate lure, a simple universal story told through the lens of a director who liked improvisation so much he'd even film his own actors' rehearsals just in case he captured something extraordinary. A director who never stopped looking for that little bit extra, and in *High Noon* found it.

10. *YOJIMBO* (1961)

In the USA in 1860, the Pony Express made its first westbound mail delivery, from St. Joseph, Missouri, over ten days across the Great Plains and over the Sierra Nevada mountains to

Sacramento in California, its single pouch containing 49 letters and five personal telegrams. In that year, Colorado was organised as a US territory, Kansas was admitted to the Union as the 34th state and Abraham Lincoln was elected the nation's sixteenth president.

In Japan in that same year, the period of the Tokugawa Shoganate was in its final throes, the *Kanrin Maru* set sail from Tokyo Bay, taking the country's first official delegation to Washington thus ending a centuries-old doctrine of seclusion, ... and somewhere in Japan a wandering samurai – a *ronin* – entered a small rural village that was being torn apart by two rival gangsters. As he made his way through the village, a stray dog walked past, carrying in its mouth a severed human hand, and with it a fistful of familiar, time-honoured western motifs. OK that last example of the *ronin* and the dog is fictional. Well, then again, it *may* have happened ...

The story at first looks familiar. The *ronin* enters the village, about as venal a village as one can imagine, its inhabitants living in fear of two factions intent on maintaining their grip on its gambling territory. The *ronin* is told there is a civil war of sorts coming to the town, and that he should give serious thought to leaving. Of course, he chooses to stay. He then begins to manipulate each faction, aligning himself first with one, and then the other, his choices governed by his only real principle: his abiding self-interest. But there's a twist. What begins as a game of cat and mouse escalates into a battle between the sword and an evil merchant class, the slaying of a corrupt oligarchy. It is a fable about the demise of capitalism – a subject close to the heart of the film's director. The fact the bad guys here are more 'gangsters' than outlaws certainly explains the violence, which is more 'gangster-like' than we're used to, more explosive. The

ronin, naturally, is invincible, and steals the show in a series of brilliant, almost improvisational, fight scenes. You know by movie's end the streets will be littered with bleeding, broken bodies.

When asked what his name is, the man (Toshiro Mifune) answers 'Sanjuro', but it is not his real name. A wandering samurai with no master, he is a 'sword for hire', a mercenary, with a body that twitches and itches throughout as he chews on a toothpick, a man who has no qualms about slicing up villians just to prove his swordsmanship. He is not, however, without a code of honour, at one point choosing to free the wife of a peasant despite the very real danger he may be captured.

Approaching the rival groups, the *ronin* offers his services as a *yojimbo* (bodyguard), but is so appalled by their grotesque wickedness he instead decides to fight them. After almost being beaten to death by one of the gangster's sons, Unosuke (Tatsuya Nakadai), who has his own pistol that he produces to kill people at the slightest of provocations, Sanjuro escapes and takes refuge before returning to the town to make one last stand against Unosuke and his henchmen, dispatching all who oppose him in a rampage of flashing steel, an orgy of violence.

Yojimbo, directed by the great Japanese maestro Akira Kurosawa, proved to be every bit as influential as his 1954 epic *Seven Samurai*, its storyline seen again in 1964 when Sergio Leone remade it, almost scene for scene, and called it *A Fistful of Dollars* (Leone, despite failing to capture its comedic satire, still got sued for making it). In 1966 Sergio Corbucci, Leone's only real 'heir' in the realm of the spaghetti western, began his film *Django* with the very same opening shot that Kurosawa creates here, showing the back of Franco Nero walking away from the camera.

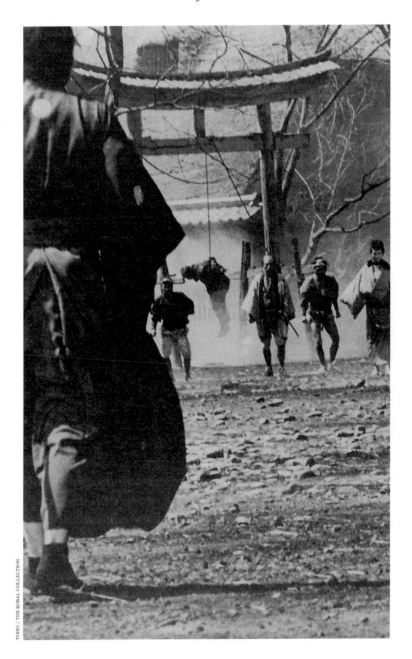

In wanting to make the action scenes as believable as possible, Kurosawa introduces the sound effect of human flesh tearing as it is cut open, thereby showing audiences just how artificial the tradition of *Toei jidaigeki*, often used in Japanese films, was, where sword fights were little more than ritualistic dances whose only purpose was to highlight the skill of the hero. He also wanted to deliver a strong social message. The rise of the Yakuza – organised crime syndicates – in post-war Japan, with all of their associated corruption and violence, had angered him to the point he wanted to make a film with a central character who could, in his words, symbolically 'mess them up'. The down-to-earth 'good' samurai of *Seven Samurai* would not be enough here. In *Yojimbo* he needed to create a 'super-samurai', a man who could put aside any notions of mercy and win against *any* odds; a samurai of the imagination.

When the American director Steven Spielberg first met Kurosawa over dinner in Tokyo, it quickly became apparent that there was no gulf, no abyss, separating Japanese and American film makers. All were doing the same work within the same artificial conditions and constraints, and for the same artistic rewards. 'It was', he said, 'just like talking to another American film maker'. Film is a common language, and genres know no boundaries. What composer wouldn't secretly wish they'd been the one to come up with Masaru Sato's memorable drumming score? What cinematographer, whether American or European or Australian, wouldn't be in awe of the wonderful compositions of Kurosawa's masterful cinematographer Kazuo Miyagawa, whose tracking shots in the previous Kurosawa film *Rashomon* (1950) are a thing of beauty? In *Yojimbo*, Miyagawa chose to use telephoto lenses and wide cinemascope to accentuate the width of the town streets, and then to shoot Sanjuro from a distance, thus emphasising his isolation and vulnerability.

There are core differences between how violence is viewed in Japan and in the west. In Japan there is a sense of futility to violence, whereas in America violence is (far too often) seen as a necessary prelude to progress. Kurosawa uses the film's excessive violence to satirise Japan's growing indifference to criminality. When Sanjuro looks down on a pitched battle between the rival gangs from the safety of a watchtower, we are right there with him, joining with him in observing the comic world of a town gone mad, a humorous, satirical look at mankind's obsession with self-destruction.

Who'd have thought a western could do all that? Or that a boy born the eighth child of a moderately wealthy Tokyo family in 1910 would grow up to become a film maker and make a film that would show Hollywood just how it should be done, and just how much they'd been under-utilising their favourite genre?

No wonder that Sam Peckinpah, the director of *The Wild Bunch*, the #1 rated western in this book, said of him:

'I'd like to be able to make a western like Kurosawa makes westerns'.

9. *MCCABE & MRS. MILLER* (1971)

The town of Presbyterian Church, somewhere deep in the mountains of America's Pacific Northwest, is a primitive stick-like mining town that grew up out of nothing and one of the bleakest, most miserable places imaginable when John McCabe (Warren Beatty) rides in to start to build a new life. With icicles on the trees and a persistently grey sky, it is the opposite of the glamorised west we're so accustomed

to seeing. He arrives with big ideas – to start a combination saloon and brothel. But when he strikes a bad deal for three prostitutes in nearby Bearpaw, he is revealed as the poor businessman he is. Constance Miller (Julie Christie), an opium addict and prostitute, then arrives and enters into a partnership with McCabe after giving him a stern lecture on the sexual realities that will face them. McCabe is bewitched by her, but his feelings are not reciprocated, hence the title *McCabe & Mrs. Miller*, the '&' denoting a corporate joining together instead of 'and', which might stand for something more intimate. The McCabe/Miller union is a business, not a romance, and even though they sleep together, he still pays her for the privilege.

So far it looks like no western you've ever seen. And that's the way it stays. Directed by maverick film maker Robert Altman, it defies just about every western convention there is. The leads are not at all heroic, nor are they even particularly likeable. There is a deliberate lack of traditional western clothing (McCabe has a wonderful fur-lined coat and bowler hat), there are no blue skies, just snow and rain, interiors are dimly lit, its early scenes look more like a series of vignettes and improvisations, and the landscape and weather are plain awful; windows are fogged up, the wind howls through cracks in the floors, the indoors almost looks like the outdoors. The narrative is character-driven and everything hinges on Beatty and Christie, who provide bravura performances, and just as well they do. They are quite deliberately the town's only two principal characters, with others coming and going from scenes before we're even given a chance to know who they are, and with no bothersome character introductions because they've all lived in the town since it was built and know who they are. There are no caricatures, and the stories of many of these strangers are left unrevealed. Much as in life, really.

The film reflects Altman's philosophy that everyone's story is worthy of telling, that one need not be heroic to have interesting experiences because drama can be found in abundance everywhere in life. McCabe, like many Altman characters, is really quite the 'loser'. He can't count, has a cowardly streak, has trouble making sense of a simple accounts ledger and has ill-conceived clashes with men more powerful than himself that get in the way of him achieving his potential. When a local mining company decides they want to purchase McCabe's new business, they send two men, Sears and Hollander, to negotiate a price with him. McCabe, however, says no. When they return to their employer without an agreement, the company then sends three men – a British bounty hunter Butler (Hugh Millais), Breed (Jace Van Der Veen) and the cold-blooded Kid (Manfred Schulz) – to kill McCabe, who, against the odds you'd think, kills Breed and Kid, though not in a heroic fashion face to face as in westerns past, but out of fear and while hiding in an open shed. In turn, wounded by Butler and appearing to be dead, McCabe shoots Butler in the forehead, then crawls through the snow back to town. Only no one knows he is there, and he dies quietly by the side of a building while the townspeople are busy putting out a fire in the local church.

The camera is used throughout as an active participant in telling the story. When McCabe takes Mrs Miller to Sheehan's saloon for a meal after she arrives in town hungry enough to 'eat a horse', Altman uses more than 30 alternating close-ups and medium shots to accompany their conversation. Elsewhere Altman uses the camera to show Mrs. Miller's primacy in the relationship by placing her in the foreground, and tracking shots that follow her as she walks through town that exclude McCabe altogether, even though he's walking

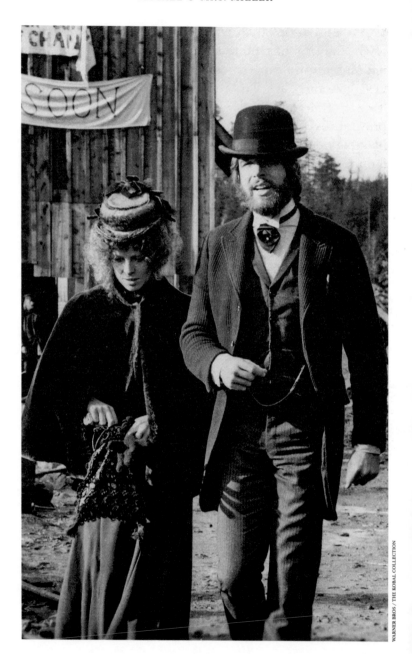

with her. Close-ups are used to highlight their isolation from the community around them. And then there is the music, not an intrusive over-scored film this one, with a Leonard Cohen soundtrack consisting of 'The Stranger Song', 'Sisters of Mercy' and 'Winter Lady', all used by Altman to provide the film with contemporary and very un-western-like rhythms. The combination of all this delivers a feel that is quite unlike any other film in the genre, a genuine one-off that positively hums with originality.

Altman smashes the stereotypes of what constitutes a western by either subverting or just plain ignoring established conventions. McCabe seems a little too feminine, while Mrs. Miller overflows with strength, aggression and masculinity. McCabe shoots two men in the back, and the assumption that decades of westerns have trained the audience to have – that every stranger represents a threat – is destroyed in the character of The Cowboy, who earlier had wandered into town in search of a whorehouse and whose innocence proves his undoing when he is gunned down on a suspension bridge by the baby-faced Kid. Instead of easy-to-follow conversations, there are moments of overlapping and off-camera dialogue where you need to really listen.

McCabe & Mrs. Miller is Altman's most cynical work, showing the frontier town not as the idyllic place of community and strength promulgated by John Ford, but as a cold, inhospitable, end-of-world backwater full of betrayal and isolation, a west built not by stoic, idealistic pioneers, but by vagabonds, miscreants ... and crooks.

8. *DJANGO UNCHAINED* (2012)

By the end of the 19th century, it's been estimated almost a quarter of all working cowboys in America's west were of African descent. African-Americans were also businessmen, cattlemen, ranchers, soldiers and outlaws. The arid plains and the Rocky Mountains did not just represent a new beginning for whites; it was a Brave New World for blacks too, both slave and free. These demographics did not go entirely unnoticed by Hollywood either, but you have to hark back a long way to find a time when it appeared to matter. In the silent days of cinema, there were movies with all-black casts, such as *The Crimson Skull* (1921) and *Black Gold* (1928), but as the genre 'evolved', the once visible face of black America in leading and/or significant roles all but vanished from the big screen.

By the 1940s the west was being depicted as a battleground with the only combatants its traditional Native American owners and waves of white pioneers. Black role models in westerns were rare. Herb Jeffries, the so-called 'black Gene Autrey' and star of several 'race' westerns in the 1930s, wasn't even black, but was of Moorish/Italian/Ethiopian heritage, and known – with all the derogatory baggage that comes with the term blackface – as the 'Bronze Buckaroo'. Was not Black America, after decades of 'raceless westerns' in which black characters were included but with race-neutral personalities, deserving if not yearning for a heroic figure who would slay all before him and redress generations of injustice – while wearing an eye-popping blue velour valet suit with white ruffles? Well, maybe people were yearning for a fictional hero and maybe they weren't. Anyway, in 2012, writer/director Quentin Tarantino decided to give them one.

The great 19th-century African-American reformer, writer and statesman Frederick Douglass once wrote that his first experience of freedom was not when he escaped to the northern states, but when he struck back at an overseer who was trying to whip him. Violence is abhorred by those who have never suffered abuse, but who says it cannot be an appropriate response to injustice by those who have? *Django Unchained*, you could argue, was a long time coming. I don't mean as a derivative of Sergio Corbucci's original *Django* in 1966, but as a symbol of righteous black vigilantism. Django (Jamie Foxx) and his beloved wife Broomhilda 'Hildy' von Shaft (Kerry Washington) are slaves who have been sold separately at a slave auction. Django is now shackled to other slaves by his new owners the Speck brothers and being marched across a desert when a German-born bounty hunter Dr King Schultz (Christoph Waltz) intervenes. Schultz is hunting the evil Brittle brothers, whom he has never seen, and Django happens to know what they look like. Django is 'forcibly purchased' from the Specks by Schultz, and agrees to accompany Schultz on his hunt for the Brittle brothers in return for his freedom.

Then comes a charming twist. Along the way Django reveals his wife, from whom he has been separated, has the German name Broomhilda, and that she can speak German – twin facts that Schultz finds astounding. Now feeling responsible for Django, whom he likens to the German mythic hero Siegfried, Schultz decides to help Django find her after the Brittle brothers are dispatched. Django and Broomhilda are reunited at Candieland, a Mississippi plantation owned by the monstrously epicurean Calvin Candie (Leonardo DiCaprio), and there is much wreaking of vengeance to come, particularly on Candie's employees and loyal house slave Stephen (Samuel L. Jackson in a masterful characterisation), before the plantation is blown up in

spectacular fashion and Django and his wife triumphantly ride off to start their new lives.

Tarantino has been criticised for his prolific use of the word 'nigger', but not once did its use strike me as gratuitous given the contexts in which it was used. Its origins come from the Latin 'niger', meaning black. It entered the French language as 'negre', then came various English derivations including 'negar' and 'niggor', before it became the derogatory phrase it has been ever since. In the southern states judges would routinely ask black defendants the question: 'Whose nigger are you?' Such examples of the word in everyday 19th-century speech were, sadly, innumerable; a common slur in an era of segregationist tyranny.

As with all great movies it has at its core a thrilling Oscar-winning screenplay written by its director, Quentin Tarantino, a scintillating text by a man who regularly smashes the boundaries that separates what is offensive from what is riotous, ebullient entertainment. In his edited final draft when Schultz gives Django a horse, Django says: 'I can't feed no horse. I can't put no horse up in no stable'. The line didn't make it into the final cut, but the realities of being black in the 1860s were never far from the writer's mind. Blacks could not own a horse, let alone feed and keep one. The sensitivity Tarantino shows for the character of Django is impressive: Django doesn't know the meaning of the word 'positive'; you can see he's never drunk beer or been inside a saloon. The childlike way Django sits and listens to Schultz expressively tell him, by the light of a camp fire, the German legend of Siegfried and Broomhilda is as tender as a child's bedtime story. The passages he specifically wrote for Waltz border on poetry and take full advantage of that actor's ability to deliver eloquent dialogue.

In the 1860s, just two years after the movie is set, almost 200,000 black men enlisted in the Union army, starting with the all-black 1st South Carolina Volunteers, to help defeat, by use of force, the way of life that came to define America's southern states. The sentiment to want to fight back has never been imagined; it isn't a fabrication of some screenwriter's fancies. I suspect the writer/director knows as much as a white man can of the complexity and tragedy of growing up black in 19th- century America.

And whether slavery was *Django*'s central theme or there just to provide the spark for an orgy of vengeance and violence, well, I don't care. Mr Tarantino, I like the way you write, boy. I'm a fan.

7. *UNFORGIVEN* (1992)

The script that provided the nucleus for *Unforgiven* had been around Hollywood for a long time as 'The Cut-Whore Killings', a title that probably goes some way to explaining why there was so little interest in turning it into a movie. And it was violent – violent to the point that when Sonia Chernus, a long-time Clint Eastwood associate, read it she thought it 'trash' and dismissed it as an 'inferior work'. Gene Hackman said he swore he'd never be involved in a movie that had the sort of violence *Unforgiven* had, but when he read the script and understood what the film was trying to say, became fascinated by its potential. Eastwood, who first read it in 1980 then put it away in a drawer for ten years, dragged it out in 1990, reread it and was so impressed with the story and characters created by its author David Webb Peoples that he

barely changed a word of it, a rarity for any screenplay. 'The more I fiddled with it', Eastwood would later say, 'the more I realised I was screwing it up'.

The town is Big Whiskey, Wyoming, the year 1881. Its sheriff, the sadistic Little Bill Daggett (Gene Hackman), doesn't like guns in his town and enforces that law with an iron fist. Trouble begins to brew though when a group of cowboys have a price put on their heads by some prostitutes after they disfigured one of their co-workers, Delilah Fitzgerald (Anna Levine). When the Schofield Kid (Jaimz Woolvett) hears of the reward, he approaches an old gunman-turned-farmer, William Munny (Clint Eastwood), to help him deliver the cowboys the frontier justice they are so deserving of. 'They cut up her face, cut her eyes out, cut her ears off, hell, they even cut her teats … a thousand dollars reward, Will. Five hundred apiece'. Munny, whose pig farm is failing and who is worried he'll be unable to provide for his wife and two children, initially rejects the idea. He seemed to be adapting to farming life, with the help of his wife, who 'cured me of drink and wickedness'. But in a few days he changes his mind and rides off after the Kid, the reward a lure he cannot resist. Along the way he links up with an old friend, Ned Logan (Morgan Freeman), and the two agree to split the reward.

Clint Eastwood kept the rights to 'The Cut-Whore Killings' until he felt old enough, his face weathered enough, to play Munny. Whether the death of Sergio Leone in 1989, followed by the passing of Don Siegel two years later, the two great directorial mentors of Eastwood's younger days, hastened its production is hard to say. Its timing was, as big budget westerns of the nineties always seemed to be, optimistic to say the least. Special effects and futuristic themes were gaining increasing footholds with movie-goers with each passing year. With the exception of *Dances with Wolves*, stagecoaches,

wagon trains and Plains Indians were struggling to find a big audience. Perhaps a western that focused on a man in the midst of his own changing times might, it was thought, find some resonance.

Eastwood's set designer Henry Bumstead created the town of Big Whiskey (and its associated farms) in the middle of Wyoming's empty, flat horizons, a location that emphasises its utter isolation. And the buildings weren't facades either, they had four walls and interiors as well, adding to the realism of the shoot. Much of the credit of how *Unforgiven* looks must go to him, but its soul belongs to writer David Webb Peoples, who had given Eastwood a first rate script. With it, Eastwood didn't feel he needed to be overtly stylistic, there were no weaknesses that required compensating. *Unforgiven* is full of ethical and moral ambiguities and there's no real answer given to the questions it raises. Munny, haunted by his own guilt, will have no happy ending to his life. There is a difference, after all, between reforming and making amends.

I've always been impressed by writers and directors who don't feel obliged to place their central characters at the heart of every scene, the relic of a bygone era of movie making. There is a confidence about *Unforgiven* that results in some lovely cameos including Strawberry Alice (Frances Fisher), the madam who raised the bounty for her tortured Delilah, and Richard Harris as English Bob, himself a former gunman now living off the fat of his own inflated legacy, but to be honest was a character the story would have got along quite nicely without. Yet he is there anyway, perhaps to provide a basis for the inclusion of the pompous W.W. Beauchamp (Saul Rubinek)?

Beauchamp writes for a pulp western magazine, and follows English Bob around everywhere like a bloodhound, mythologising him with every stroke of his pen. Beauchamp

is typical of the film's moral ambiguity, not much caring if the accounts he is writing of the life of English Bob are fictitious or true. For me, though, he is more than that. In his character can be seen the opportunists who distorted the truth of the west, who gave us false histories, who told us General George Custer was a great military strategist when in fact he made blunder after blunder, who raised Wyatt Earp from ordinary lawman to demigod and transformed Jesse James from murderer to folk hero. Truth can easily mutate into misinformation, and misinformation further into a cloak over all our eyes.

The lowly Beauchamp is the film's true villain, and if all *Unforgiven* did was remind us that much of what we know of the west might be the fictionalised outgrowth from tiny kernels of truth, then that would have been message enough. But it achieves far, far more than that.

6. *TRUE GRIT* (2010)

If I want to watch a western that recreates the vastness and open horizons of the old west, I drag out *Dances with Wolves* or *Open Range*. If I want to see beyond the mythologised west and be immersed in the lawlessness and brutality of the frontier, it's *The Wild Bunch* or *Unforgiven*. If I want to see a characterisation of a historical figure that can't be beaten in *any* genre, I watch *Tombstone* to see Val Kilmer's portrayal of John Henry 'Doc' Holliday, or Brad Pitt's take on Jesse James in *The Assassination of Jesse James by the Coward Robert Ford*. But if all I want to do is 'listen' to a western, if I were on a road trip, say, and images weren't an option, I'd listen to *True Grit*.

The feel of the dialogue with its near-absence of contractions was not something the talented Coen brothers, Joel and Ethan (who co-wrote and directed the film), sought to achieve. The words, which at times roll off the tongue like a Robert Frost poem, a sort of western frontier version of Shakespeare, were already there in Charles Portis' novel *True Grit*, which was first published in serial form in 1968 in the *Saturday Evening Post*. What the Coens did, in an effort to remain more faithful to the characters than the 1969 film version starring John Wayne, was lift Portis' words from the book – which the Coens loved so much they read it to their children – straight to the screenplay. Portis, who didn't assist with the screenplay and has never shown any enthusiasm for transferring his own words to the big screen, looked at how people spoke in the southwest USA in the late 19th century. His characters possess a kind of homespun correctness, and there's also a lot of gnarling and gnawing of Cogburn's lines so that you really need to cock an ear occasionally to follow what is being said. All part of the charm.

It is the absence of contractions that is most apparent. America was not without contraction-less speech in the 1870s, yet Portis made the absence of them a general rule of thumb. There are barely any contractions in the screenplay: no 'it's' and 'he's', just 'it is' and 'he is', though occasionally the Coens would allow Jeff Bridges as Cogburn to slip in an occasional contraction as the Portis book isn't entirely without them. (And nor was America. In *Tom Sawyer*, published in 1876, Mark Twain wrote 'won't' 58 times and 'will not' just once!) Nevertheless it certainly makes for interesting prose, and perhaps the formal diction shouldn't come as a surprise. At a time when most people were illiterate to one degree or another, what schooling they did receive came out of the

pervasiveness of the King James version of the Bible and the language used reflects that formality. Forget the fact that several hundred westerns made up to this point collectively failed to realise that 100 years ago this is how people may well have spoken.

True Grit is the story of a fourteen-year-old girl from Yell County, Arkansas, Mattie Ross (Hailee Steinfeld), who enlists the aid of US Marshal Reuben 'Rooster' Cogburn (Jeff Bridges) to help her bring to justice Tom Chaney (Josh Brolin), the man who shot and murdered her father. They are joined in their journey through the forbidding Indian Territory of the Choctaw Nation by a Texas Ranger, La Boeuf (Matt Damon), who clashes constantly with Cogburn and leaves to pursue Chaney on his own. La Boeuf returns just in time to prevent Chaney from killing Mattie, knocking him unconscious to the ground, then helping Cogburn defeat the notorious Ned Pepper gang, which Chaney had joined. Chaney is killed after he comes to, strikes down La Boeuf and is then shot in the chest by Mattie, who falls backwards into a pit and is bitten by a rattlesnake. Cogburn scoops her up in his arms and rides through the night with her on her horse Little Blackie, which Cogburn pushes on until it drops from exhaustion. He then carries Mattie the rest of the way to a doctor, saving her life.

True Grit 2010 is superior to the *True Grit* of John Wayne. The slovenly, down-and-out appearance of Jeff Bridges is much closer to the Rooster Cogburn envisioned by Portis than was achieved by Wayne, who wore a hairpiece and a corset during the filming. Matt Damon is head and shoulders above what was a lively performance by Glen Campbell as La Boeuf, and the beautiful and talented Hailee Steinfeld as Mattie Ross steals almost every scene. After all, this is her story: she set in motion the fight for justice and fuelled the

pursuit of Tom Chaney, and it ends with her 25 years later (played by the gifted stage actress Elizabeth Marvel) visiting the grave of her old friend Cogburn, with whom she had 'lively times'.

And then there is the music. Composed by Carter Burwell, the score consists of variations on the old hymn 'Leaning On The Everlasting Arms' (1888), 'The Glory-Land Way' (date unknown), 'Hold To God's Unchanging Hand' (1905), 'What A Friend We Have In Jesus' (1868) and 'Talk About Suffering' (date unknown). Moody and evocative, Burwell's Protestant hymns are given new life with sorrowful piano arrangements that all speak of and give expression to the character of Mattie, and provide the film with a deeply felt moral centre. The score is one of Burwell's finest, though it is a pity it wasn't considered at Oscar time – it was deemed to have been composed with 'a reliance on pre-existing themes'.

For me it is its imaginative phrasing, so precisely and eloquently crafted, that lifts it so high. 'His spirit has flown'; 'You give out very little sugar with your pronouncements'; 'I do not entertain hypotheticals, the world itself is vexing enough'; 'I'm a foolish old man who's been drawn into a wild goose chase by a harpie in trousers and a nincompoop'; 'He is not my friend. He has abandoned me to a congress of louts'.

Poetry, in the guise of a screenplay.

5. *C'ERA UNA VOLTA IL WEST/ONCE UPON A TIME IN THE WEST* (1968)

It's my very favourite first ten minutes in cinema. Three gunmen – Stony (Woody Strode), Snaky (Jack Elam, the town drunk in *High Noon*) and Knuckles (Al Mulock) – wearing full-length canvas or oilcloth coats called dusters arrive at a remote rail station surrounded by a vast platform of railway sleepers in the middle of an American desert. They are waiting for a train. There is no dialogue, just a succession of carefully orchestrated sounds: a windmill persistently squeaks, spurs jangle, water drips with a pat-pat-pat onto Stony's hat, the tick-tick of a ticker-tape machine, the buzz of a fly crawling on Snaky's face that refuses to go away, lured there, if you must know, by jam smeared on Elam's face by the film crew in the hope one of a jar-full of flies would land on him. Elam traps the fly in the barrel of his gun, and the sound of the fly in the barrel becomes the next sound. The tension is ratcheting up, notch by notch, all the while the most audacious, triumphal set of opening credits is unfolding, like everything else here. Slowly.

The train is heard in the distance. A low-angled shot of its approach, a perspective reminiscent of the one John Ford set up in *The Iron Horse* back in 1924, is thrilling and will be one of countless references Italian director Sergio Leone makes here to the genre he loved so much. The train pulls in, and so now there is a new sound – the wheezing and hissing and groaning of the locomotive. It then pulls away, and the man the three gunmen have been waiting for is left standing before them. The inevitable gunfight you waited twelve minutes for is over in seconds. This is not a film about violence, it's about the moments in between the violence.

The man from the train has been hit, but only winged, while three great character actors lay dead. You've been sitting in the dark for almost thirteen minutes now, and though barely a word's been spoken, plenty's been said. This is Sergio Leone at the top of his game.

After his success with *The Good, the Bad and the Ugly*, Leone announced, just as Hollywood studios were reaching a crescendo of interest in him, that he was through making westerns. 'I've said all I wanted to say', he remarked, referring to the genre. Well, maybe he hadn't really thought that sentiment through. When Paramount offered him a budget he couldn't refuse and the chance to work with Henry Fonda, an actor he had admired from before he became a film maker, he couldn't resist. Soon, in the grey sands of northern Spain and in the red dust of Utah's Monument Valley, Leone discovered there was a lot of stuff he hadn't yet said.

The plot centres on the struggle over a plot of land outside Flagstone, a stop on the coming railway line, between the McBain family who own the land and a railway tycoon who hires Frank (Henry Fonda) to acquire it for him by whatever means he can. Frank massacres the McBain family (father and three children), yet he is himself pursued by the mysterious man on the train (Charles Bronson) who plays the harmonica, and plays Frank, too, toying with him throughout the film while all the while intending to kill him at a time of his own choosing, and whose motives are not revealed until the final scene. Meanwhile, Jill McBain (Claudia Cardinale) arrives in Flagstone and sets about asserting her rightful claim over the property called Sweetwater, which has a fresh water source beneath it; water that will be needed for the coming age of steam. And an age of corrupt capitalism

too, it seems, seen in the portrayal of the crippled railroad tycoon Morton (Gabriele Ferzetti), which gives the film a decidedly Marxist tilt.

The camerawork borders on the exquisite. When Jill McBain arrives in Flagstone on the train, the finest tracking shot Leone had achieved to that point in his career follows as the glorious music of Ennio Morricone swells, and a crane shot reluctantly moves away from the beautiful Tunisian actress to reveal the fledgling town, a real town complete with alleyways, not just facades, all created by production designer Carlo Simi at a cost of $250,000, more than the whole budget for *A Fistful of Dollars*.

Time is dragged out here, distended, its set pieces artificially elongated. Things that can be done in seconds take minutes. It's been called an opera, a dance. 'Real time' has no consequence. And it is a movie full of archetypes, the re-telling of old, familiar stories. Leone had no intention of making a 'new' western, something that went where no other had before it. Instead he wanted to immerse himself in the genre. Young Timmy McBain goes hunting with a wooden gun, just as young Joey did in *Shane*. The names McBain and their ranch Sweetwater are lifted from *The Comancheros*. The three gunmen waiting at the railway station mimic those waiting for Frank Miller at the Hadleyville railway station in *High Noon*; the rustling bushes, flighty pheasants and the quieting of cicadas just before the McBain massacre are an unashamed steal from *The Searchers*. Jill's arrival at the trading post in the desert is a clear reference to James Stewart arriving at the trading post in *Winchester '73*. And on it goes. There are countless references, all seamlessly interwoven to tell a 'new' old story; and because of this, it is a film for the western's true 'fans'. The more you know, the more you'll see.

So why does Harmonica kill Frank? A series of flashbacks throughout the film of a man emerging through the desert haze, always with his face hidden, is suddenly revealed. It is Frank, only much younger, and a much younger Harmonica, too, whose brother has been made by Frank to stand on Harmonica's shoulders, a noose around his neck tied to a bell under a Roman arch smack in the middle of Monument Valley. There are maybe a handful of images in the history of cinema that can rank with this. Frank then shoves a harmonica in the young man's mouth, who struggles to support the weight of his older brother but then finally collapses into the dust, having been kicked away by his brother. The motivation of the older man we know as Harmonica has been revealed.

And so, the final confrontation, the shootout we've waited three hours to see ... heralded by three minutes of orchestral splendour then a duel that's done with in the blinking of an eye. Actions that traditionally took minutes taking only seconds, and seconds, minutes. A final lesson from the master of silences and gestures.

4. *SEVEN SAMURAI* (1954)

There had never been a film in the history of Japanese cinema like Akira Kurosawa's *Seven Samurai*. An epic struggle between good and evil, a classic tale of defeat and victory, its violence and physicality were overwhelming, its quieter moments dripping with humanity and pathos. A humanistic story of how heroes are capable of defeating the emergence of evil, there is none of the Hollywood 'grand show' here,

no establishing shots, no broad cinematic horizons showing a somehow mythic landscape, no shallow characterisations. Here were heroes whose violent-prone natures didn't mean they were incapable of seeking self-actualisation, of finding the better angels of their nature. A perfect union of philosophy, of things said, of action and of nature, it is as potent today as the day it was made.

To watch *Seven Samurai* is to ache for humanity and to feel the chaos of battle. The final confrontation goes on for almost twenty minutes, the nuances of its composition making it one of the pinnacles of world cinema. Never just violence for the sake of violence, it was nevertheless far more than the watered-down kubuki-derived fights of the past, possessing an almost poetic choreography. As he would do with *Yojimbo* seven years later, Kurosawa dismantled the ritualistic and stylised tradition of *Toei jidaigeki* swordplay. In *Seven Samurai* every death is keenly felt; it is brutish, nasty, without a hint of glamour. After decades of Japanese cinema depicting samurai as artful 'supermen', here at last was a film that showed them as the flawed, troubled men they were.

The plot is straightforward. A 16th-century Japanese village is being raided by a gang of bandits. After consulting with a town elder on what to do, some villagers go to a local town samurai are known to frequent and hire some *ronin* – wandering samurai with no master – to protect them. The samurai are individually introduced over the first third of the film, with Kurosawa labouring over the development of their individual personalities, which are all highly defined and distinct. The leader is the wise but war-weary Kambei (Takashi Shimura), there is the temperamental Kikuchiyo (Toshiro Mifune), Shichiroji (Daisake Kato) an old friend of Kambei's, the charming but less skilled Heihachi

(Minoru Chiaki), the supremely skilled stony-faced Kyuzo (Seiji Miyaguchi), the tactician and skilled archer Gorobei (Yoshio Inaba), and the young Katsushiro (Isao Kimura) who desperately wants to be Kambei's disciple and who is invited to become the seventh samurai. The villagers, too, are thoughtfully portrayed, especially the elderly Yohei (Bokuzen Hidari), whose face provides an aching picture of just how much the village has suffered at the hands of the bandits, with his small pot of rice the only 'wealth' he possesses. The villagers are grateful for the samurais' intervention, but at the end of the movie when the bandits are defeated and only three samurai remain, thoughts turn to the coming spring and the planting of new crops. So the remaining samurai say their goodbyes, and they are gone.

Much imitated in western cinema in the years that followed, *Seven Samurai* was never going to make a seamless transition into the American idiom. The hierarchical structures in 16th-century Japanese society bore little resemblance to those in 19th-century America. The samurai–farmer relationship was very different from that of the gunman–farmer. Samurai, being in effect the servants of noblemen, made them very much a part of the aristocracy, a world apart from the peasants they defended. In America, however, the distinctions between gunmen and farmers were not so clear. Cowboys, farmers, sheriffs, blacksmiths – these were all pioneers, all cut from the same cloth, separated only by degrees, by the choices they made and lifestyles they chose to follow. And yet all of the themes that make a western a western are undeniably present here: the remote frontier-like setting, the absence of law and order, a nervous citizenry, the extended battle sequences, and at its core a number of righteous heroic male figures. All very familiar themes and a not-unfamiliar setting, with

regional warlords presiding over a feudal, emerging nation struggling to define itself.

Kurosawa edited his own work, too, a rare thing for the times. But more than anything it was Kurosawa's obsession with movement – *any* movement – that gave it its beauty. Whether it be wind, rain, snow or fire, he was the master of movement, always surprising, always cinematic, always finding room for an aspect of nature, even if it was only through the window of an interior scene. The film is a sequence of flawless compositions that engage the audience through movement. In that final climactic battle scene, Kurosawa used several cameras so he could later edit with a greater degree of precision and continuity, a process Sam Peckinpah would use to great effect in *The Wild Bunch*, which was considered ground-breaking in 1969, yet here was Kurosawa doing it in Japan fifteen years earlier! He also used the 'wipe', the sliding of a vertical line across the screen to change a scene and denote the forward passage of time from one scene to the next. Every conceivable technique and trick was used: wide shots for reduced emphasis, sustained wide shots to create tension, jump shots, cuts on action, quick cuts and telephoto lenses to add a sense of claustrophobia, deep-focus photography so that backgrounds and foregrounds were all in focus simultaneously thus immersing the viewer in the scene.

In my formative, less enlightened days, all I was ever grateful to Kurosawa for was providing the template for John Sturges' *The Magnificent Seven*, the favourite film of my childhood and early adult years. Now here I am decades later, a lot older and hopefully a little wiser, and my gratitude to Kurosawa knows no bounds. And as much as I am wedded to Yul Brynner and his six fellow gunmen, the truth is Sturges' derivative lacked the philosophical depth and cinematic

grandeur of this timeless masterpiece. Well, it was filmed in America after all, and as Kurosawa once said with a hint of disparagement:

'Gunslingers are not samurai'.

3. *NO COUNTRY FOR OLD MEN* (2007)

Imagine a world where violence is everywhere – pervasive, perennial, inevitable. A world with rampant moral ambiguities, with a system of justice that is either irrelevant or at best compromised serving a polite society that struggles to impose itself upon the wild frontier that surrounds it – and on the miscreants that walk its streets. Now imagine an author who combines all of those themes then adds greed, opportunism, a relentless pursuit, an author who imbues his protagonists with a pitiless thread that empties them of their humanity. Reads like a western doesn't it? The book, a jewel of literature, is read by two film makers who love subverting established norms. They realise its genius, and turn it into a movie. But instead of 1880's Tombstone with wagons and Winchesters it's 1980's Texas with pick-up trucks and a captive bolt pistol. Times have changed. People have not. Welcome to the world of the neo-western.

No Country For Old Men, written and directed by Joel and Ethan Coen, who adapted the screenplay from the book by Cormac McCarthy, is set in 1980 in West Texas, El Paso and the Texas/Mexico borderlands. It tells the story of Llewelyn Moss (Josh Brolin), who, while out hunting deer in a West Texas desert, stumbles across a drug deal gone horribly

wrong. With the dead and bloodied bodies of two rival gangs (as well as a bloated, bullet-ridden dog) spread out about him, he finds a lone survivor in a pick-up truck, too weak to move, and the body of a man who had tried to get away but now lies dead against a tree – and a bag containing more than $2 million in cash by his side. Moss, the 'everyman', does what we all would likely do – he takes the money and clears off. It could have been the perfect getaway, but returning home to his girlfriend Carla (Kelly Macdonald) he finds he is troubled that he left a man there to die, and returns to the scene with some water.

It is now night, and the man has died. Just as he is about to leave, however, a series of headlights appear over the crest of a nearby hill, and the movie's subtitle comes back to haunt us: 'There are no clean getaways'. Moss escapes the scene, but the money has a tracking device embedded in it and he finds himself being pursued by the relentless and completely unhinged Anton Chigurh (Javier Bardem), who has been hired to retrieve the money, a fact that should have come as no surprise to Moss, who knew the money to be 'dirty', the product of evil men. Rounding out the trio of male leads is Sheriff Ed Bell (Tommy Lee Jones), representing the 'old men' of the title. A lawman hopelessly out of touch with the new breed of organised criminal, he is in desperate need of retirement. No one says 'sir' or 'ma'am' anymore, he bemoans. An old man chasing shadows, he no longer recognises the changing world around him.

In the Coen brothers' world, the 'old west' may have passed, but our psyches are much as they've always been. These remote Texas landscapes are still a fertile breeding ground for the sort of messed-up psychotics and weak-willed opportunists the west always had in abundance. Chigurh is possibly the most psychopathic individual the west has

ever had. 'Change' is slow to happen in the Coen universe. Their tell-tale 'trick', employed in crane shots where the line of an empty horizon is kept in the same place because the camera focuses increasingly upwards as the crane is lowered, suggests movement without change. The sort of greed that Moss gives into in taking the money has no boundaries in time or place. Civilisation is everywhere here, more enveloping and pervasive than ever, yet it is still in the background, ambivalent and neutral. When Chigurh chases Moss through darkened streets, you don't see another soul; an urban expanse as deserted as any frontier landscape, leaving room for the playing out of all the old, familiar themes.

The characters may be costumed in the spirit of the genre, but they are not heroic, the morality of the traditional western is missing. Moss deliberately acts against his own conscience in stealing the money, then descends toward the level of his pursuer by threatening to come after him. There isn't even a final showdown, one of the traditional western's 'must haves', with Bell turning up too late to save Moss from his execution. Chigurh too turns on its head the psychology of the villain, defying comprehension, denied a speech to give some context to his behaviour. The tossing of a coin to see if someone lives or dies makes his actions impossible to predict, save for the relentless pursuit of his victim. His morality is complex and distorted; he is the personification of chaos.

No Country For Old Men contemporises the genre as neo-westerns do, making allowances for changing times while retaining elemental themes. There is the clever transitioning between old ways of life and a coming newness – one of the old western revisionist themes – seen here in the overwhelming complexities that come with the arrival

of a new type of criminal, and how Sheriff Bell finds himself unable to comprehend their methods. Much of the familiar iconography is still here too in the way the actors are dressed. Instead of fringes, spurs and lassos, however, now we have plaid shirts, stetsons, patterned cowboy boots, western-style button-down shirts and blue jeans; still the clothes of the cowboy, whose spirit is timeless.

The film is so expansive and possesses so many elements, it almost defies classification. I cannot recall a film having such an ever-present sense of dread hanging over it, and a narrative so relentless in its push forward towards an inevitably grim conclusion. It is a reminder that the western is not a rigid, easily defined genre, but a living, evolving thread that continues to run through the heart of contemporary America, and always will.

2. *IL BUONO, IL BRUTTO, IL CATTIVO/THE GOOD, THE BAD AND THE UGLY* (1966)

Sergio Leone's Italian/Spanish masterpiece about a trio of egocentric vagabonds – Clint Eastwood, the 'good' Blondie; Lee Van Cleef, the 'bad' Angel Eyes; and Eli Wallach, the 'ugly' Tuco – on a Homeric journey through America's Civil War to find $200,000 in Confederate gold was the latest in his emergent tradition of violating everything the American western stood for. The product of an inventiveness born of low-budget films (that were now very *big* budget films), Leone's directorial 'sixth sense' infused his work with stylistic beauty that ran hand-in-hand with examples of

extreme violence. The third of his Dollar westerns, filmed in the deserts of southern Spain, deserts that bore enough of a resemblance to the America/Mexico borderlands, his theme of the anonymous drifter and bounty hunter who cared only for money and the exacting of revenge against anyone who got in the way of him finding that money, which began with *A Fistful of Dollars*, had evolved and flowered ... and become art.

The Good, the Bad and the Ugly, with the exception of its principal actors, was filled with unknown Italian extras, their English dubbed, their acting occasionally questionable. Yet it captured the imagination of audiences at a time when Hollywood westerns were losing their way, because Leone infused what would became his trio of epics with ingredients American film makers appeared to have forgotten about: dishevelled villains with no ethical boundaries, sometimes with no names, always merciless, their violence set against a backdrop of unforgiving, barren landscapes. But there was more. There was no attempt at moralising. Images enter frames unexpectedly throughout, like the opening sweeping long-shot that is miraculously transformed into a signature Leone close-up when the stubbled face of a cowboy suddenly lurches in front of the camera lens, or how an entire Civil War encampment floods the frame when moments earlier Blondie and Tuco seemed entirely on their own. What lies beyond the edge of the frame matters. The story is not limited to what the audience can see.

A black comedy about the futility of war, the film is a series of perfectly crafted vignettes. In its opening scenes there is no dialogue, and natural sounds are used to introduce and increase tension, such as the flapping of canvas and the 'crackle' of boots walking on gravel. Later in the film, Blondie is in his hotel room with his Navy Colt in pieces as

he cleans it. A Union army marches past outside, its noise muffling the footsteps and the wonderful tinkling of spurs of the men coming down the hallway to kill him. He only hears them when the army halts its march, thus giving him time enough to load his gun and kill them. The scene in the gun store where Tuco is choosing a gun and improvises with gestures is funny if you know Wallach knew absolutely nothing about guns and was encouraged by Leone to simply follow his instincts as an actor.

In the film's final scenes, Tuco's frenzied running through thousands of graves in his search for the grave of Arch Stanton, which he has erroneously been led to believe contains the gold, is made operatic by Leone's masterful direction and soaring music with its mariachi-style trumpets, piano and choir. Morricone's eccentric approach to orchestration here takes centre stage, with his unconventional instruments combining with a melodic gift that cannot be taught. What he did here conveyed to composers everywhere that music was no longer just a background device, it had the potential to become every movie's unseen superstar. In this score you're listening to one of the 'holy trinity' of film music: there is the two-note ostinato of *JAWS*, there is *Star Wars*' Imperial March, and there is this. And chasing these three, there is daylight.

When Tuco thinks he has found the grave with the gold, Angel Eyes appears. When the grave is opened and is empty, Blondie reveals he is the only one among them who knows its true location. He seems to write something on the bottom of a flat stone, which he places at the centre of the arena-like cemetery. The three man then spread out from each other in preparation for the final shootout. Morricone's music is as essential here as music is to opera. What he and Leone achieve in these few minutes is the finest marriage

of music to film ever achieved. When they were together and at their best, I mean at their very *very* best, there was no collaboration that could touch them. And what they achieved here, what followed from the moment that stone fell from Blondie's hand, was the finest two and a half minutes of film ever made.

The final gunfight, known as the 'Trio' scene, between Tuco, Blondie and Angel Eyes in the middle of Sad Hill Cemetery contains more than 65 cuts, and is a triumph of editing; of eye-line matches, over the shoulder shots, close-ups of weapons, medium close-ups, tight close-ups, moving from one character to another, but all arranged with great purpose to tell a story. Tuco's eyes shift back and forth because he is nervous, but Angel Eyes gets the most shots because he is the most perplexed: just who should he shoot? Tuco and Blondie are looking at one another, perhaps building an alliance? But the outsider Angel Eyes' concentration is split. The editing tells us all of this. Then extreme close-ups come faster and faster, the music soars, and at the end of a bewildering and ground-breaking montage of images and angles, someone shoots.

Yes, it lacks dialogue, but images can transcend the spoken word by virtue of their composition form. Here we see a cinematic rebuff to the idea in architecture that 'form follows function'. Not here, not in Leone's universe. To him, form is *everything*, and you'd be silly to argue. After all, the man had just finished creating his very own genre.

1. *THE WILD BUNCH* (1969)

When I look back over the history of the western, from the twelve remaining silent minutes of *The Great Train Robbery* in 1903 to the present day and all the westerns that are still to come, I'm increasingly comfortable with the idea that the genre falls into two time periods: those films that came before *The Wild Bunch*, and all those that have followed since. This shocking, poetic, epic film delivered realism in a way no American film of any genre had ever done. Gunfights were choreographed with the finesse of a dance, violence slowed down so we could better indulge in its twisted nuances. It was filled with characters you despised, but oh how you wanted them to survive. Like so many other movie-goers, I was unprepared for the images director Sam Peckinpah had so technically and intricately, and in some cases spontaneously, orchestrated in a theatrical display of bloodletting – not to mention a string of lesser moral and ethical ambiguities – that together had no precedent. And though I struggled sorting out the jumble of feelings that watching it had brought me, I saw enough through an emotion-laden fog to know I wanted more. Was this what movie making was supposed to be all about? Full of slow-motion killing captured with multiple cameras, quick-cut editing, and with a finger held up to studio executives and to an industry that, because it had been in the midst of bringing changes to its codes of practice, gave the film the window it needed in order to be released the way it was? I felt somehow betrayed. If *this* is what movies *should* be like, if this is what they *can* be like, then what had I been fed at the movie houses all these years? Why weren't *all* films made like this?

In a world where audiences wouldn't become desensitised to violence for maybe another twenty years, *The Wild Bunch* was a shock, a revelation and a triumph on every level. Filmed entirely on location in Mexico, the year is 1913, and a gang of ageing outlaws are living along the Texas/Mexico border, pushed to their country's fringes in order to survive. They are a group of men who are incapable of change seeing the world they know changing all about them. Civilisation is closing in, motor cars are on the streets and the First World War is just a year away. Banks are becoming harder to rob. The army rides railway carriages to protect their cargoes.

The film begins with the Bunch entering a Texas border town to rob a railroad office of its silver, but instead wander into a rooftop ambush by some scurvy-looking bounty hunters hired by the railroad to kill them. An unfortunately timed temperance march down the main street provides the surviving members of the Bunch with enough cover, courtesy of the marchers' increasingly bloodied bodies, felled in the film's ground-breaking first ten minutes, to slip out of town for an unlikely escape.

There isn't a weak link in the acting chain. The Bunch – William Holden (Pike Bishop), Ernest Borgnine (Dutch Engstrom), Warren Oats (Lyle Gorch) and Ben Johnson (Tector Gorch) – are superb, ably backed up by Robert Ryan (their chief pursuer, Deke Thornton), Edmond O'Brien (Freddie Sykes), Jaime Sánchez (Angel), the Mexican film director and personal friend of Peckinpah's, Emilio Fernández (Mapache), and two of Thornton's bounty hunters – L.Q.Jones (T.C.), and Strother Martin (Coffer). The group consider the mutilation and robbing of the many corpses generated in their pursuit of Pike and his gang *de rigueur*, their gleeful depravity laying waste to long-established Hollywood notions of decorum.

Peckinpah's west, coming to a close though it was, is still a dirty, horrid place, without so much as a nod given to the sanitised west so long promulgated by Hollywood. Peckinpah hated facile violence, violence that had no sting in its tail. But critical reaction to the violence was predictably mixed. John Wayne remarked after seeing it that it had single-handedly destroyed the myth of the old west. When a reporter asked Peckinpah at a press conference why the film had ever been made at all, he replied: 'We wanted to show violence in real terms. Dying is not fun and games'. When another asked: 'Why did everyone bleed so much?' Ernest Borgnine couldn't contain himself. 'Lady', he said, 'did you ever see anyone shot by a gun without bleeding?'

The editing, which was snubbed at Oscar time by an Academy that seemed unable to fathom its ground-breaking method of quick-cutting, was the product of editor Lou Lombardo, whose work on this film would go on to influence generations of movie makers. The final gun battle, which the film's crew nicknamed The Battle of Bloody Porch, was shot over twelve days using six cameras, all set at different perspectives and shooting at speeds ranging from 24 to 120 frames per second. When the filming wrapped up, it took Peckinpah and Lombardo another six months to complete the overall editing – in excess of 3,640 edits – more than five times the average for a Hollywood movie, with its resultant montage effect providing the audience with a far more immersive experience. Time was stretched out, the violence more visceral.

Peckinpah was born in the west at a time when it still possessed the remnants and echoes of the 1880s. He hung out with wranglers and ageing prospectors on his grandparents' ranch on the eastern side of California's Sierra Nevada mountains, listened to stories of the old

west and learned how to ride a horse. In his own words, he 'witnessed its disintegration'. In Hollywood in the 1950s, he cut his teeth working for director Don Siegel before moving to television and finding his niche in various westerns, writing scripts for shows such as *Gunsmoke* and *The Rifleman*. In 1962 he directed his first feature, the now-classic western *Ride the High Country*. Peckinpah venerated the old west but, unlike John Ford, Howard Hawks and others of their era, he refused to mythologise it (an ode to Billy the Kid in *Pat Garrett & Billy the Kid* notwithstanding?). And while John Wayne and his old director buddies may well have lamented its passing at his hands, the rest of us – not to mention the genre itself – are all the better for the uncompromising genius and artistry of Hollywood's 'blood poet'.